The
PARISIAN
woman's guide to
STYLE

by Virginie and Véronique Morana
Photography by Philippe Sebirot

UNIVERSE

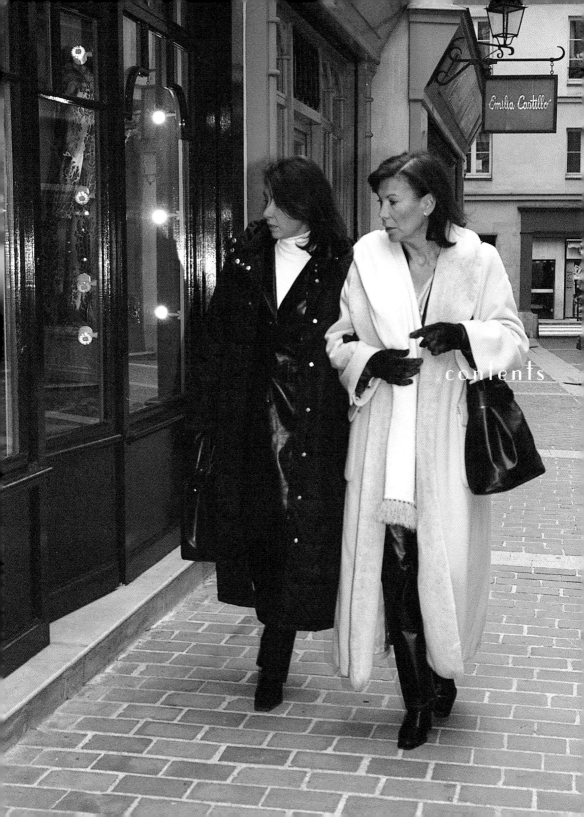

contents

First published in the United States of America
in 1999 by
UNIVERSE PUBLISHING
A Division of Rizzoli International Publications, Inc.
300 Park Avenue South
New York, NY 10010

Copyright © 1999 Universe Publishing

Text and captions translated by Abigail Wilentz
Photos conceived of and styled by Virginie and
Véronique Morana
Design by Ivette Montes de Oca

00 01/10 9 8 7 6 5 4 3 2

ISBN: 0-7893-0372-8

Printed and bound in Singapore

Library of Congress Catalog Card Number: 99-71283

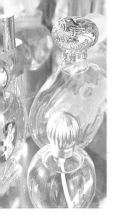

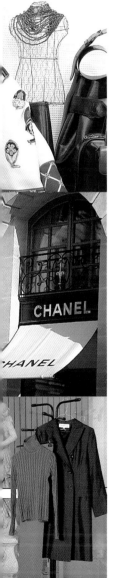

INTRODUCTION

Paris, 10 a.m.: The city bustles with activity. People rush full-speed ahead—striding down the sidewalks, hurrying towards the metro, ducking into taxis. The word of the day: *Vite! Vite!* "No time to waste!" The Parisian woman is on the run like the rest, but her slender silhouette is unmistakably elegant in a close-fitting suit, an attractive bag at her side, and a scarf knotted neatly at her neck. She rushes though the crowd on delicate heels. Her allure is decidedly discreet and subtle, even sober at times, in line with her oft-repeated expression, *Je ne voudrais pas que cela fasse trop!* "Let's not overdo it." At all costs, she veers away from stylistic extremes: too smart or too flashy, even too chic. Her ensemble might seem hastily put together and deceptively simple at first glance, but upon closer inspection, it becomes clear that each element has been carefully considered, from the choice of basic wardrobe pieces to the essential details—the bag, shoes, scarf, and jewelry. Despite the appearance of effortless chic, the overall effect has been constructed with great precision.

This restrained, classic style spans generations—mother's and daughter's silhouettes are practically the same. Unlike past decades, when generation gaps were discerned by distinctive styles, women of different ages are now dressing more and more alike. With equally active lifestyles, mothers and daughters seek the same comfort, elegance, and ease, as well as sexiness—at any age the *Parisienne* wants to be seductive as ever. To keep up with the times, a working woman must maintain a modern, dynamic appearance, so the opinions of her daughter are indispensable. Mother and daughter now shop together and even borrow each other's clothes. Naturally, each adapts the fine points of her outfit according to her age. In this respect, the details make all the difference; the working woman might opt for a more sophisticated look with classic gold jewelry, a silk scarf, and heels, while her daughter in college might prefer trendy silver jewelry, a crushed-velvet scarf, and sneakers. Many French designers have picked up on this

mother-daughter trend and are marketing their merchandise accordingly. Brands like Agnès b., Claudie Pierlot, and Morgan, as well as the couture houses, are launching younger, hipper advertising campaigns to attract the attention of young women who will have their mothers in tow—instead of the other way around.

However, women's style in Paris is by no means homogenous. The predominant looks today fall within three distinct categories: "la branchée," "l'avant garde," and "la BCBG." La branchée, which literally means "trendy" refers to the woman of the Left Bank, particularly of the quartier Saint-Germain, who might be an artist or student. She typically adheres to the intellectual look, *le look intello*, which would include long, masculine-looking coats, leather jackets, heavy shoes, little makeup, and very short or dramatically long hair. The women who are regulars at Café Deux Magots or Café Flore—renowned artists' hangouts—favor an androgynous look, stripped of frivolous detail. Their nonchalant attitude would suggest they pay little attention to dress, but don't be fooled: their style is as calculated as any other.

In the Marais, Bastille, and Les Halles, the haven of daring young designers, we find l'avant garde, the woman whose look is cutting-edge. Excess—not moderation—is her rule of thumb, whether it be in cut or color. This style of dress frees a woman to experiment; truly nothing shocks. You can expect to find the look of l'avant garde in the trendiest clubs—from daring hair colors, to enormous platform heels, to whimsical boas and other such attention-getting accessories.

Though both la branchée and l'avant garde make their presences felt in Paris, they do not represent the brand of Parisian style for which the city's elegant women are known. Rather, the look foreigners tend to associate with Paris is that of the BCBG —*bon chic bon genre*—woman of the Right Bank, Neuilly, and the 16th arrondissement. It is this category we will stay closest to in the pages to come, though we will venture beyond the most conservative guidelines of traditional BCBG style to offer a more well-rounded view of the Parisian woman today. For the Parisian woman's look is anything but static. She follows the fashion shows throughout the year and is aware of the latest trends around the world. She travels more than ever. In a matter of hours she can reach London by train. She will spend a weekend shopping in Rome, Madrid, or New York. This guide cites many renowned French names in fashion, but even these designers have been influenced by international design. Of course, the Parisian woman still upholds her signature French style, but she has incorporated into her wardrobe accents from Italy, Spain, England, America, Japan, and more, maintaining her basic principles of good taste while constantly evolving with the times.

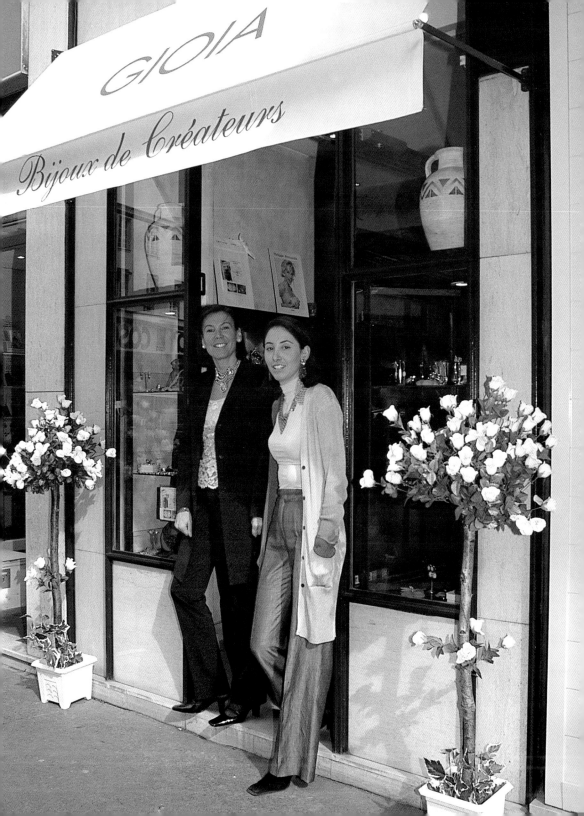

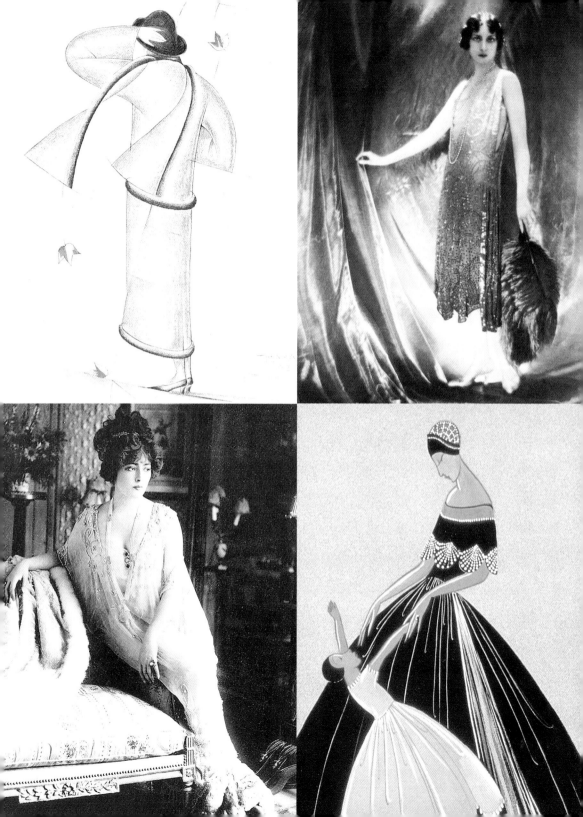

CHRONOLOGY OF FRENCH FASHION

From Hermès to Chanel to Lacroix

1774 Rose Bertin

The first woman to be a professional fashion designer, Bertin opened her Paris shop on rue Saint Honoré in 1774. At the recommendation of a client, the Duchesse de Chartres, Bertin became Marie Antoinette's fashion adviser and was nicknamed the "minister of fashions." Bertin dominated clothing and hair styles throughout the reign of Louis XVI.

1837 Hermès

Founded by Emile Hermès in 1837, Hermès first specialized in horse tack and saddlery, but soon expanded into couture—gloves, watches, and jewelry. Hermès went on to become a leading French luxury brand, with an emphasis on durability, elegance, quality, and simplicity. The first item of clothing with the Hermès label was a suede golf jacket with a new innovation—a zipper. Hermès was the first to use the zipper, and the jacket had great success. In the 1930s several now mythical items were introduced: the dog collar belt, the trademark square silk scarf or "carré"—so popular that items such as a dress and a bathing suit were made out of the same fabric—and the future Kelly bag—so named when the bag was pictured with Grace Kelly on the cover of *Life* magazine in 1956.

1850 Redfern

John Redfern opened his first shop in London in 1850 and in 1888 was conferred the designation "By appointment to Her Majesty the Queen and HRH the Princess of Wales." Today Redfern is remembered for having invented the modern suit for women.

1854 Louis Vuitton

Opening its first store in 1854, Louis Vuitton advertised itself as "the spirit of travel." Two years later Vuitton presented a trunk specifically designed for train travel—the classic Vuitton trunk was born. This model was followed by the waterproof trunk, as well as those with features such as copper locks, interior drawers, and compartments for hanging clothing. To protect against being copied, Vuitton created their famous monogram in 1896. By 1959 Vuitton turned to the production of soft, functional bags to accommodate new modes of travel. Today the sale of Vuitton bags has spread to over forty countries throughout the world. The monogrammed line is still the most popular and represents eighty percent of Vuitton's sales.

1857 Worth

Charles-Frederick Worth established the tradition of presenting collections twice a year, which allowed the designer to dictate the newest trends each season. His fashion shows featured young models commonly known as "*Les Sosie*," or the doubles.

1875 Doucet

Friend to Impressionists such as Monet and Degas, Jacques Doucet was the first couturier to belong to the intellectual set. Influenced by the artistic styles of his friends, his colorful designs reflected art trends of the time.

1885 Lanvin

In the 1920s Jeanne Lanvin dressed several women in theater and film, including the leg-

endary Arletty in the classic *Les Enfants du Paradis.* Inspired by art and clothing of the past, she favored taffeta and organdy for evening dresses, which she often embellished with embroidery of historical motifs. Her most famous creation was the full-skirted dress "de style," inspired by eighteenth-century dresses. By the 1930s her designs included fantastic details such as spectacular sequined wings and breastplates. In 1922 Lanvin presented her celebrated perfume, Arpège. Its gold, ball-shaped bottle was one of the most notable bottles of the decade.

1891 Paquin

Since her first collections, Jeanne Paquin was admired for her audacious use of contrasting fabrics and expensive furs, which she treated as dress fabrics. In an era before conventional advertising, Paquin took it upon herself to promote her label among well-dressed society by attending horse shows escorted by models dressed in her latest designs.

1895 Callot Soeurs

The daughters of a painter and a lace maker, the four Callot sisters were unsurprisingly renowned for their work in lace and other trimmings. They created dresses entirely out of lace and mixed different types of lace within the same dress. Avid admirers of orientalism, their designs after 1910 showed a distinct Asian influence. Madeleine Vionnet began her career here, claiming she owed her expertise in the architectural aspects of fashion design to the Callots.

1903 Paul Poiret

Like Schiapiarelli and Chanel, Paul Poiret was an avid promoter of the arts. Fascinated by the magic of orientalism, Poiret created brightly colored tunics and made the rose his symbol. He presented the first fashion show that traveled throughout Europe—a catalyst of the idea of fashion movements. Poiret introduced the *chemise* dress and the *jupe-culotte* and created the first line of beauty products linked to a couture house. He also liberated women from the corset: in 1910 he replaced black stockings with flesh-colored ones and substituted the traditional corset with the girdle, introducing a modern, slender silhouette. Asserting that fashion guides the ways of society, Poiret pronounced that the couturier had a voice to be heard.

1910 Chanel

Opening her first boutique—a millinery salon—in 1910, Coco Chanel was destined to become one of the most influential couturiers of all time. A champion of easy, unconstrained elegance, she introduced the use of practical and comfortable fabrics such as tweed and jersey. Women are indebted to Chanel for her creation of trousers and the little black dress, which first appeared in 1926. Chanel also created the classic, two-toned sling-back pump, the quilted handbag, and her signature, two-piece tweed suit with braid trim and brass buttons—equally appropriate for day or night, summer or winter. Her innovations include using sumptuous costume jewelry in couture and launching the first couture perfume, the ever-popular Chanel N°5.

1912 Madeleine Vionnet

Inspired by the look of ancient Greece, Madeleine Vionnet's basic design was a simple rectangle of fabric attached at the shoulders and fastened at the waist. Instead of working on a live model, she used a small wooden doll. Her dresses were light as lingerie, and her models presented them without wearing corsets and with bare feet. Draped in soft folds, her clothes allowed freedom of movement while emphasizing a woman's natural curves. Her bias-cut dresses

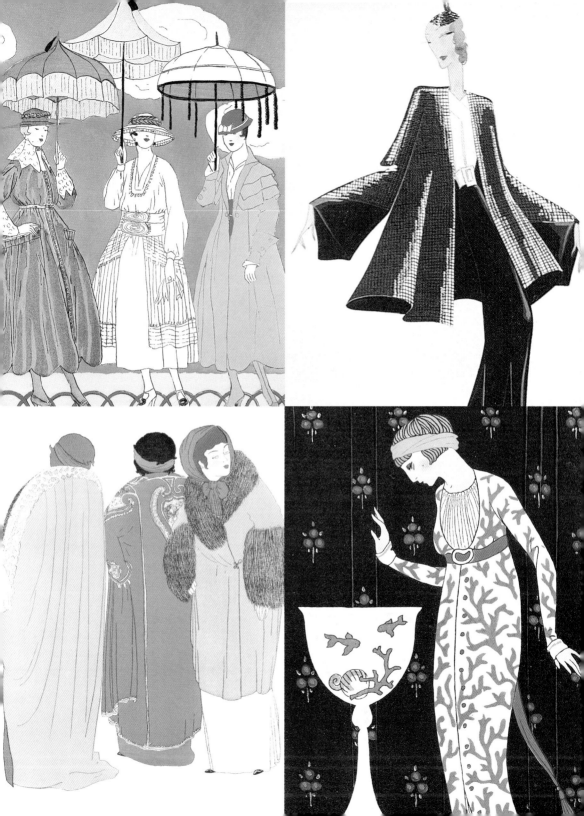

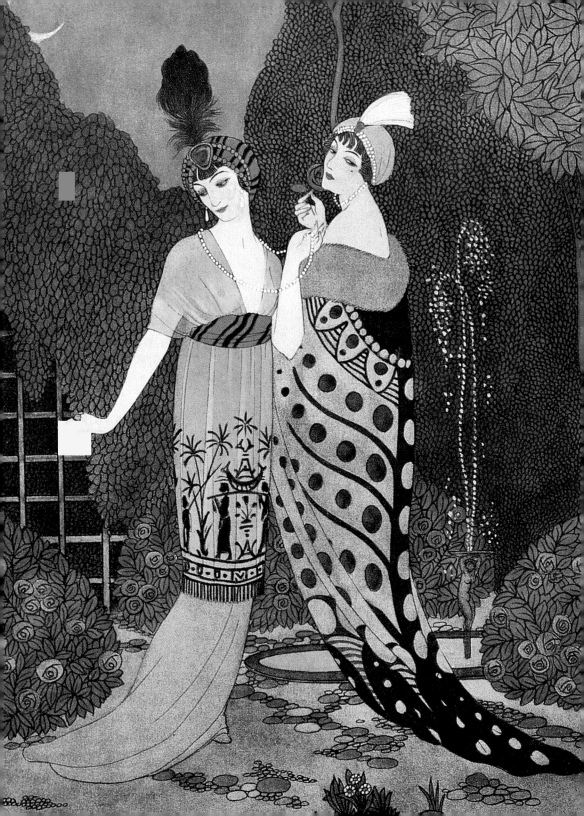

in crepe, taffeta, and lace (by the house of Lesage) embodied 1930s elegance.

1914 Patou

Originator of modern sportswear, Jean Patou designed clothes for golf and tennis, including the first cardigan and the first tennis skirt. In 1924, Patou became the first couturier to feature his monogram as a motif on sportswear. He created the first knit bathing suits as well as the first suntan lotion entitled Huile de Chaldée. In 1930, Patou presented his renowned fragrance, Joy.

1919 Rochas

Focusing on the modern feminine silhouette, Marcel Rochas greatly explored the possibilities of bias-cut fabric, and was known for revealing the underlying structural elements of a garment, from the ribs of a bodice to the square shoulder of a coat. He designed the famous black-and-white Bali dress, inspired by the supple Balinese dancers he had viewed at a colonial exhibition in 1931. Other trademark pieces included the Canadienne, a long jacket marked either by gathers or a belt at the waist, and the famous Guepière jacket, foreshadowing the line of the New Look so popular in the 1950s. He is also remembered for his line of frivolités, which included bags, gloves, and scarves—all decorated with black lace.

1927 Schiaparelli

Inspired by art deco and cubism, "Schiap," as Elsa Schiaperelli was known, created a style at once classic and shocking, using trompe l'oeil and fanciful themes such as the circus or astrology. Upon the opening of her store on rue de la Paix, she debuted an amusing new sweater adorned with a butterfly bow, which proved an instant success. She surrounded herself with artists such as Salvador Dalí and Jean Cocteau and incorporated surrealism into her designs— her famous shoe-shaped hat is probably the best known of her imaginative accessories. Her trademark suits were recognized for their tight waists, padded shoulders, and novel, sculptural buttons. Also known for her daring capes and evening wear embroidered by Lesage, Schiaparelli adopted shocking pink as her signature color.

1929 Mainbocher

Mainbocher was the first American couture house in Paris. Equally audacious in his designs for day and night, Main Rousseau Bocher created evening dresses in unheard of casual fabrics such as cotton piqué and men's shirt fabric, while at the same time presenting sporty jackets in fine fabrics normally reserved for evening wear. In 1934 he introduced the first strapless evening dress with whalebone stays.

1931 Jacques Heim

In addition to his haute couture collections first presented in 1931, Jacques Heim created designs for the beach including the Tahitian-style pareo, or wraparound skirt, and, most famously, in 1932, the two-piece bathing suit, which would become the bikini. In 1936 he introduced Heim Jeunes Filles, a department within his showroom that offered clothing specifically designed for young women—a revolutionary concept soon to be adopted throughout the world of fashion.

1932 Nina Ricci

In her designs, Nina Ricci sought to highlight each woman's personality. Known for her moderate prices and outstanding fit, Ricci brought back a natural feminine silhouette, both colorful and ample in form, including her famous, colorful, jersey-knit cape with a flounced edge. Throughout her career, Ricci was characterized by a traditional elegance.

1935 Balanciaga

Cristobal Balanciaga opened his first shop in Barcelona in 1935 but did not open his Paris boutique on the avenue Georges V until 1948. Balanciaga selected runway models based on their unique physical characteristics rather than on traditionally beautiful features. His landmark designs included balloon dresses, fitted suits, tunics, peasant blouses, and the chemise or sack dress, which was adopted by women worldwide. Balanciaga's designs were easily recognized for their elegant silhouettes. His day ensembles were deceptively simple and his extravagant evening gowns claimed the highest prices of their day. As opposed to the popular silhouette of the New Look, his fitted look symbolized restrained elegance throughout the 1950s. His superb fittings were renowned; Marlene Dietrich claimed that one of Balanciaga's fittings was equivalent to three of any other designers'.

1937 Jacques Fath

While working with American Joseph Alpert, Jacques Fath visited New York twice a year to present his collection of at least forty designs per season. His creations were marked by asymmetry, new color combinations, and elongated silhouettes that exaggerated the curve of the thigh and bust. The house of Fath was also noted for its exquisite collection of lace stockings.

1937 Jean Dessès

Jean Dessès specialized in ball gowns of draped mousseline, either in soft shades or contrasting colors, often embellished with beading and embroidery. Later Dessès added lines of elegant cruisewear, lingerie, and nightwear.

1940 Madeleine de Rauch

Inspired by her three sisters, who were avid sportswomen—one an accomplished skater, another an equestrian—de Rauch opened her couture house in 1927 to offer elegant sportswear to women. Her first perfume, Peach, maintained the theme with a golf-ball-shaped stopper.

1941 Grès

Born Germaine Emilie Krebs, "Madame Grès," as she came to be known, brought neoclassicism back into style with her innovative use of drapery in supple fabrics, especially silk jersey. She was, in fact, the first designer to use the fabric—it was especially fabricated for her. She created her signature Grecian look by folding fine pleats into the fabric and then sewing each one down individually.

1944 Carven

Using a modification of her first name, Carmen de Tomaso founded Carven in 1944, designing for petite, thin women like herself. She created a green-and-white-striped dress, entitled *Ma Griffe*, "My Signature," which was so successful that she launched her now-classic perfume under the same name. Beginning in 1965 she designed stewardess uniforms for international airlines including Air India, SAS, Aerolineas Argentinas, and others.

1945 Balmain

Pierre Balmain's first collection gained instant attention for its starkness of line, holding close to the body. Dubbed "Le Nouveau Style Francais," his look included highly defined shoulders, an emphasis on the chest, and a narrow waist, often raised to elongate the legs. Any fullness in form he reserved for coats. Whether designing suits, cocktail dresses, or evening gowns, Balmain upheld a look of natural simplicity. Beginning with his fall/winter collection of 1952–53, he named all of his collections Jolie Madame after his successful perfume, launched in 1949.

1946 Christian Dior

After Christian Dior's legendary runway show in 1947, Carmel Snow of Harper's Bazaar noted, "What a revolution, my dear, your dresses have a wonderful new look." In contrast to Poiret and Chanel who liberated the modern woman from restrictive clothes, Dior took a step backward to restore a sophisticated, ultra-feminine silhouette marked by cinched waists; busts lifted over tight, bone-lined bodices; full, calf-length skirts; and coolie hats perched on neatly coiffed heads. Dresses were severely narrow for day, full-skirted for cocktails, and long and majestic for evening. Some defining pieces included mink stoles; double-strand pearl chokers; cartwheel hats; barrel coats; the H, A, and Y lines; the sheath dress; and the chemise or sack dress. Since his emergence on the scene of haute couture, Dior has remained a worldwide symbol of French fashion and Parisian elegance.

1950 Louis Feraud

Louis Feraud opened a boutique in Cannes in 1950 with his wife, Zizi Feraud. Thanks to actresses who purchased his clothes, such as Brigitte Bardot, the shop enjoyed a quick success. At his first fashion show in 1958, Feraud was singled out by a Saks Fifth Avenue buyer, who signed a contract with him that would last seventeen years.

1952 Givenchy

Hubert de Givenchy offered appealingly easy-to-wear clothes with a design that allowed the modern woman a new freedom of movement. His collections demonstrated at once a mix of classicism and fantasy, including playful elements such as fake pockets, buttons that were impossible to close, and printed patterns of good luck charms. The popular French model Bettina was his star model and publicist, while his eternal muse was Audrey Hepburn.

1953 Pierre Cardin

Pierre Cardin began his career at the house of Dior. Once he was on his own, the quality of his workmanship, the refinement of his fabrics, and the originality of his concepts attracted a sophisticated clientele. Themes in his permanent repertoire include asymmetrical necklines, scalloped edges, fan-pleated panels, and exaggerated buttons. Cardin was known for his sculptural shapes, as demonstrated in his enormously successful bubble dress in 1954. Fascinated by the space launches made in the 1960s, he presented the Cosmos line in 1966, a practical unisex look that included a short tunic over a fitted, jersey, ribbed sweater and tights for women or trousers for men.

1961 Yves Saint Laurent

Another disciple of the house of Dior, Yves Saint Laurent became Christian Dior's successor when he was only twenty-one years old. In 1966, he was the first couturier to launch an independent ready-to-wear line—Saint Laurent Rive Gauche. Known for his strong, severe cut and simplicity of colors, Saint Laurent experimented with androgyny, introducing in 1966 "le smoking," a tailored evening suit adapted from the man's smoking jacket, and in 1968 the Safari look with its audacious, laced-up safari jacket. Highly influenced by modern art, his strikingly contemporary collections paid tribute to such artists as Mondrian, Picasso, Braque, and Warhol. His muse was legendary French film star Catherine Deneuve.

1961 Courrèges

Though the house of Courrèges was founded in 1961, the famous boutique with its stark, white decor did not open its doors until 1965. Known as "la bombe Courrèges," André Courrèges created a major impact on the basic contents of

women's wardrobes. His accessible styles used synthetic materials such as vinyl and nylon, often in a forgiving, trapeze shape that did not have a waist or hips. His trademarks included the sensational miniskirt, pants for any occasion, the jacket with snaps, flat shoes, woolen tights, and his signature white boots. He described white as "the color of light," explaining his ongoing penchant for the color.

1968 Sonia Rykiel

Known as the "Queen of Knits," Sonia Rykiel exploded onto the fashion scene with her little, fitted sweater that appeared on the cover of *Elle* magazine in 1962. In 1968 she opened her own shop, with clothes for the liberated woman made of airy, fluid fabrics. Her clothes were marked by an elongated, clinging but supple silhouette. Always innovative, she introduced novel ideas such as wearing clothing inside out—making the seams equally important as the surface.

1973 Thierry Mugler

In 1973 Thierry Mugler presented his first collection, Cafe de Paris, based on the image of the seductive *Parisienne* in ultra-feminine, figure-defining ensembles. His trademark look is daringly close fitting, with large, square, padded shoulders. From Amazon to Hollywood diva, the Mugler woman is at once devastatingly sexy and supremely powerful.

1976 Jean-Paul Gaultier

Jean Paul Gaultier shocked the world with his first collection in 1976, which featured straw "tablemat" dresses. Inspired by post-punk, London street wear, Gaultier is renowned for exploring the gender boundaries of fashion, incorporating themes of social movements and popular culture, as well as experimenting with new forms of technology. Landmark designs include the skirt for men in 1985 and Madonna's notorious, cone-shaped bustier in 1990. The enfant terrible of haute couture, Gaultier continues to question conventional definitions of beauty and taste.

1987 Christian Lacroix

Inspired by his background in theater and the folklore of Provence, the land of his youth, Lacroix's first collection in 1987 brought extravagance and excitement back to haute couture. His vision of the modern Parisian woman was apparent in his first show, offering strapless evening dresses with a defined waist and a full skirt that allowed the legs to move freely. After a long-time preference for simple, full-length evening dresses, Lacroix popularized the short evening dress—extremely ornate with sumptuous embroidery; rich, colorful fabrics; and dazzling costume jewelry. His incredibly elaborate dresses are often considered more suitable to theater than to real life, and, accordingly, his colorful designs have been featured in opera and ballet performances in both Europe and the United States.

A<small>RT</small> . G<small>OÛT</small> . B<small>EAUTÉ</small>

FEUILLETS
DE
L'ÉLÉGANCE FÉMININE

PARIS

N° 28 - 3ᵉ Année NOËL 1922

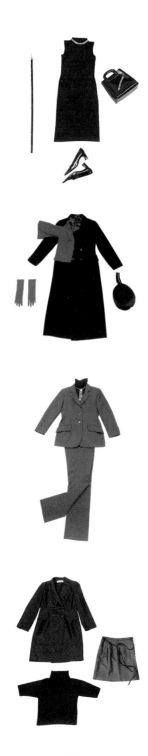

THE
ESSENTIAL
WARDROBE

The Basics

The formula for
Madame is elegant
simplicity. Whatever
else she chooses
to add to her
wardrobe, her most
important pieces
consist of the funda-
mental skirt,
jacket, and pants—
preferably black.
With these three
basic items she is
prepared for any
occasion.

THE SUIT
Staple of the Modern Woman

The suit is a perennial favorite with the Parisian woman. According to the hour and occasion, it can be easily adapted with a change of the top under the jacket–from a casual T-shirt to a sophisticated bustier. Adding to this versatility, the same jacket and pants can also be worn throughout the greater part of the year, as Paris maintains practically the same climate from September to June–gray, cloudy, and humid, with temperatures in the fifties. On more wintry days, the Paris woman simply adds a coat, scarf, and gloves.

For a weekend-casual look, the suit is dressed down with a T-shirt. A favorite style among Parisian women is the classic, round-neck T by Petit Bateau, size "16 *ans*"–the size is meant for teenagers, so the look is neat and fitted. Depending on the degree of informality, she might choose a pair of trendy sneakers, such as New Balance or No Name, or a comfortable, flat shoe such as J.P. Tod's or Weston moccasins. While different brands vary in price, the overall look is relaxed but always chic.

For work, the suit looks smart with a turtleneck, a blouse–by Cacharel for example–or even a twin-set, with the cardigan wrapped around the shoulders. Low-heeled shoes ($1\frac{1}{2}$–2 in.) complete the look.

For evening, the suit becomes elegant with a strappy little top, a bodysuit, or a bustier. Add shoes with a higher heel (2–$2\frac{3}{4}$ in.) or even spiked heels ($2\frac{3}{4}$–$3\frac{1}{4}$ in.) for the appropriate occasion.

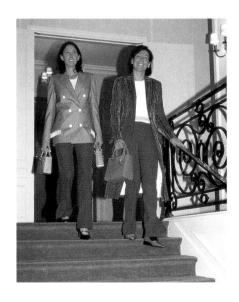

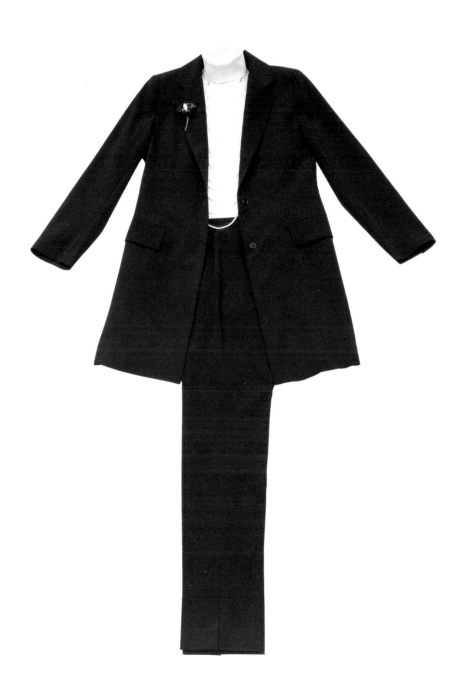

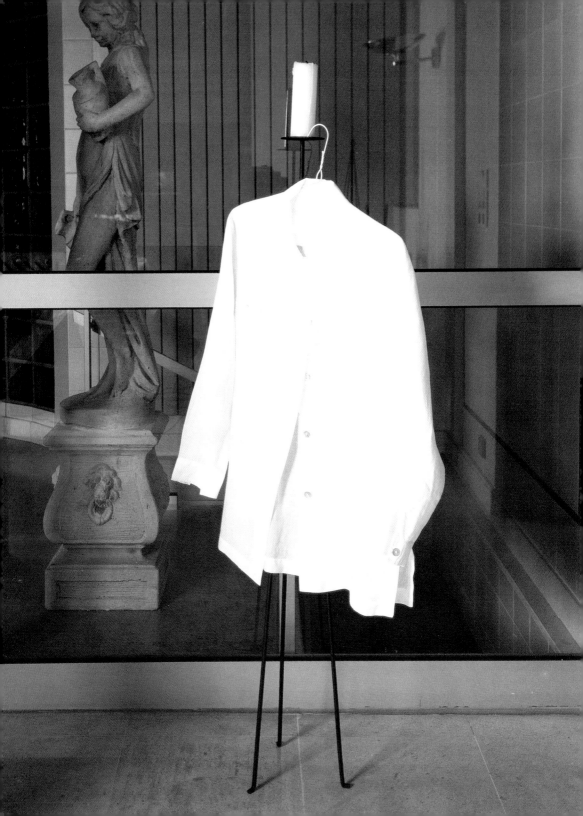

THE WHITE SHIRT
The Perennial Neutral Base

The only wardrobe element that changes with different trends is the shirt the Paris woman wears with her classic suit or jeans. There are many recent incarnations of the white shirt. The boxy Agnès b. shirt—very similar to a man's shirt—was very popular at one time but has been superceded by a more tailored look. Similarly, the white blouse worn with a knotted scarf or tie in the style of St. Laurent or Chanel has practically disappeared, making way for the T-shirt and cardigan and for the merino wool or cashmere twin-set. The overwhelming preference du jour is the fitted, cotton T-shirt, especially the one by the classic, French brand Petit Bateau—it is a nostalgic favorite for the Parisian woman, as Petit Bateau has long been indispensible for high-quality children's clothes. This is not to say that the classic, white shirt has disappeared. While the fine points of its design continue to change according to taste and trend, the white shirt remains an undisputed basic item in the Parisian woman's wardrobe.

THE LITTLE BLACK DRESS
From Day to Evening

Originally brought into vogue by Coco Chanel, the little black dress continues to reign supreme in the realm of versatile elegance. The dress' form—from conservative to revealing—and fabric—from wool-crepe to stretch-lycra—may vary through the years, but it is always versatile enough to be a basic.

A discreet look for day is a simple dress accessorized with a belt; black, low-heeled shoes; a simple, black leather bag; and classic jewelry such as a gold or silver chain or a string of pearls. The dress might also be worn with a fitted, black, suit jacket—taken from the classic, black suit in every woman's wardrobe—and a colorfully printed, Hermès-style silk scarf to add a touch of color.

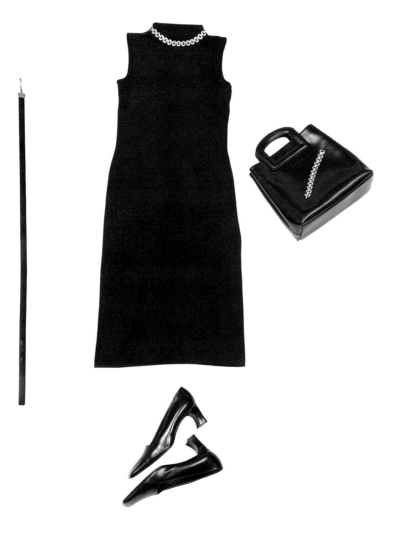

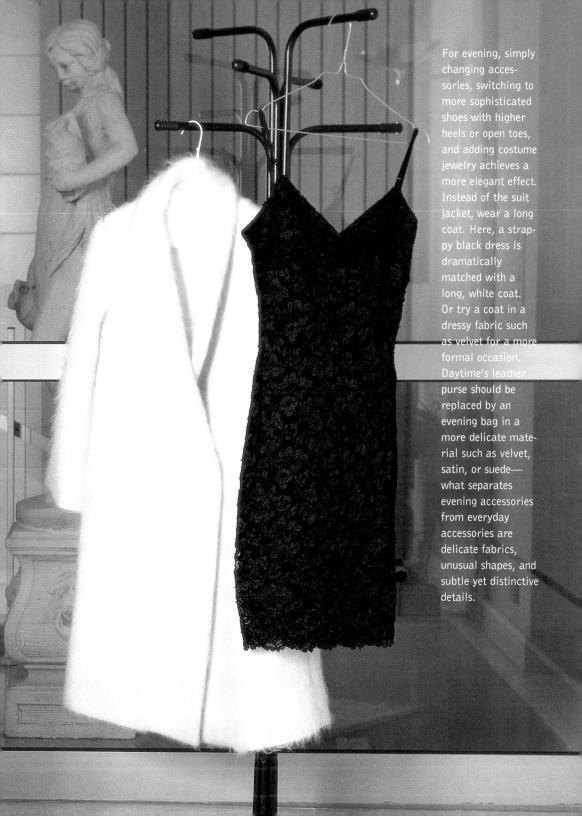

For evening, simply changing accessories, switching to more sophisticated shoes with higher heels or open toes, and adding costume jewelry achieves a more elegant effect. Instead of the suit jacket, wear a long coat. Here, a strappy black dress is dramatically matched with a long, white coat. Or try a coat in a dressy fabric such as velvet for a more formal occasion. Daytime's leather purse should be replaced by an evening bag in a more delicate material such as velvet, satin, or suede— what separates evening accessories from everyday accessories are delicate fabrics, unusual shapes, and subtle yet distinctive details.

COLOR
Tone-on-Tone Neutrals

The Parisian woman most often chooses clothing in basic, neutral colors, such as dark brown, steel gray, navy blue, sandy beige, khaki, deep bordeaux, ivory, and white—but overall, the favorite remains black. These colors are the basis of her wardrobe because they are practical, economical, and appropriate for the gray, Parisian climate. The emphasis is on *passe-partout*, "versatility"—the colors of an outfit should work as well for a board meeting as for dinner or cocktails. Above all, neutral colors are essential wardrobe basics because they never stand out in a crowd. The Parisian woman's respect for classic, good taste motivates her to dress so that she will blend into any social milieu.

Outfits are carefully coordinated around a dominant color—an ensemble may include all shades of gray, bordeaux, or brown. More often than not, the Parisian woman's choice of color demonstrates an overall sense of restraint. While the individual pieces of different outfits may be mixed and matched, the colors may not. She tends not to experiment with unusual juxtapositions of tones but stands by favorite combinations such as navy and white or beige, brown and beige, white and beige, pink and gray, or, above all, black and white—always chic and in good taste.

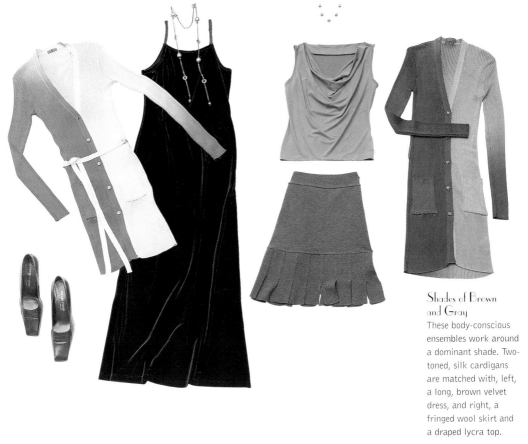

Shades of Brown and Gray
These body-conscious ensembles work around a dominant shade. Two-toned, silk cardigans are matched with, left, a long, brown velvet dress, and right, a fringed wool skirt and a draped lycra top.

LINE
Sleek Silhouettes

As a general rule, the line of French clothing is very close to the body, as Parisian women of all ages seek to maintain a young, feminine allure. Because of new stretch-fabrics, clothes are more body conscious than ever before. Unlike years past, when women resorted to corsets and other body-shaping aids, today's stretch-fabrics combine comfort and fashion, allowing clothes to be close fitting without being restrictive. As a result, modern women favor stretch-fabrics in everything from dress pants and jeans to T-shirts, sweaters, and jackets.

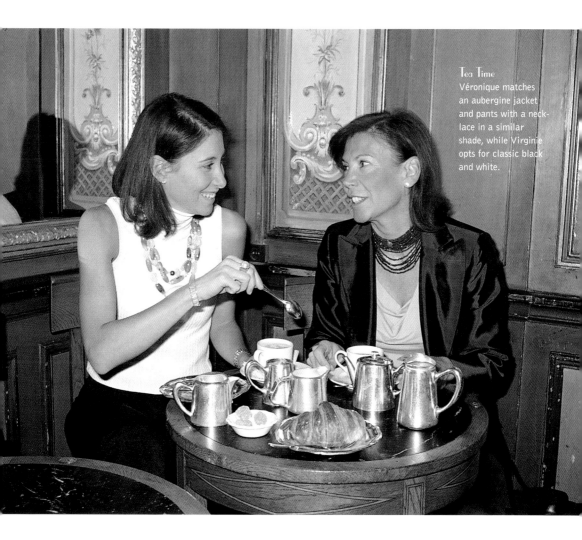

Tea Time
Véronique matches an aubergine jacket and pants with a necklace in a similar shade, while Virginie opts for classic black and white.

THE SEASONS
Autumn Winter Spring

The French woman does not significantly alter her wardrobe from autumn to winter to spring since the climate in Paris rarely changes dramatically—most days are rainy, cloudy, and gray. Keeping things simple and economical, she merely adds layers to her basic wardrobe according to the moderate changes in temperature of each season.

Sporty Sophistication

For autumn/winter, a look of easy elegance: brown stretch-pants with a long, brown, wool jacket/sweater, a brown turtleneck, and brown, leather boots. According to the weather, switch the boots for low-heeled shoes and the turtleneck sweater for a pullover sweater. The chic French woman would accessorize with a logo belt by Hermès, Gucci, or Gampel and a chunky silver chain; the luminous details are successfully set off by the somber tones of the clothes.

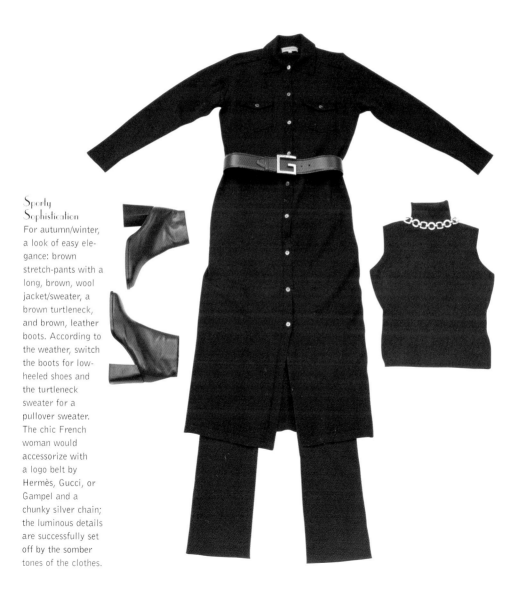

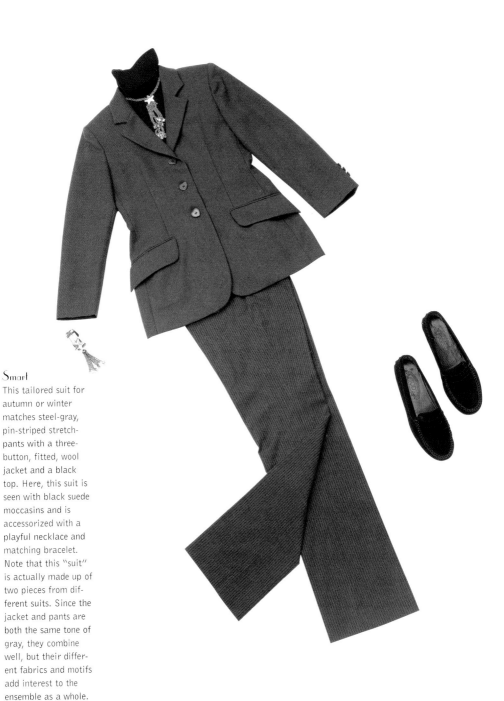

Smart

This tailored suit for autumn or winter matches steel-gray, pin-striped stretch-pants with a three-button, fitted, wool jacket and a black top. Here, this suit is seen with black suede moccasins and is accessorized with a playful necklace and matching bracelet. Note that this "suit" is actually made up of two pieces from different suits. Since the jacket and pants are both the same tone of gray, they combine well, but their different fabrics and motifs add interest to the ensemble as a whole.

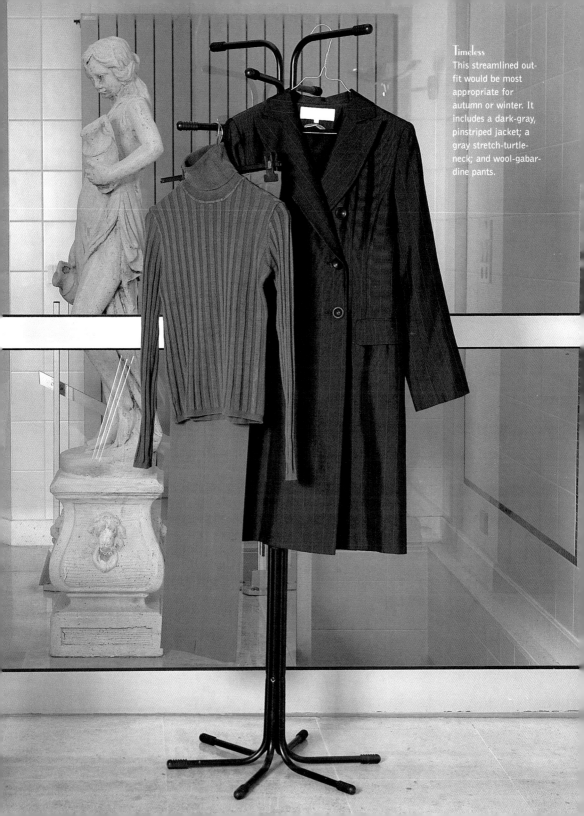

This streamlined out-
fit would be most
appropriate for
autumn or winter. It
includes a dark-gray,
pinstriped jacket; a
gray stretch-turtle-
neck; and wool-gabar-
dine pants.

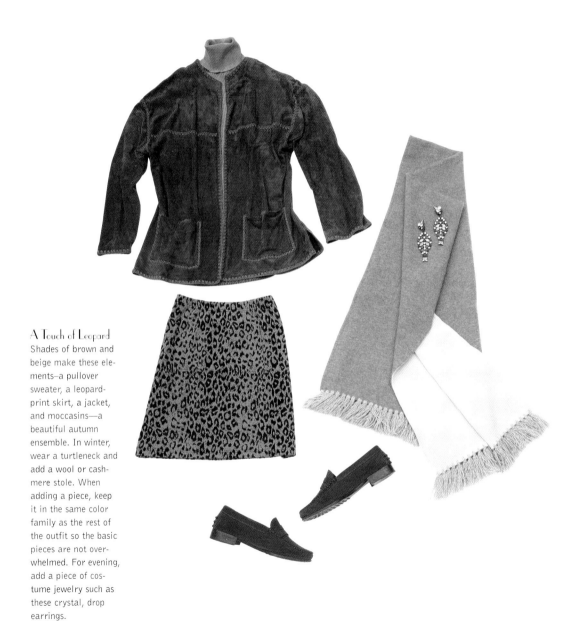

A Touch of Leopard

Shades of brown and beige make these elements—a pullover sweater, a leopard-print skirt, a jacket, and moccasins—a beautiful autumn ensemble. In winter, wear a turtleneck and add a wool or cashmere stole. When adding a piece, keep it in the same color family as the rest of the outfit so the basic pieces are not overwhelmed. For evening, add a piece of costume jewelry such as these crystal, drop earrings.

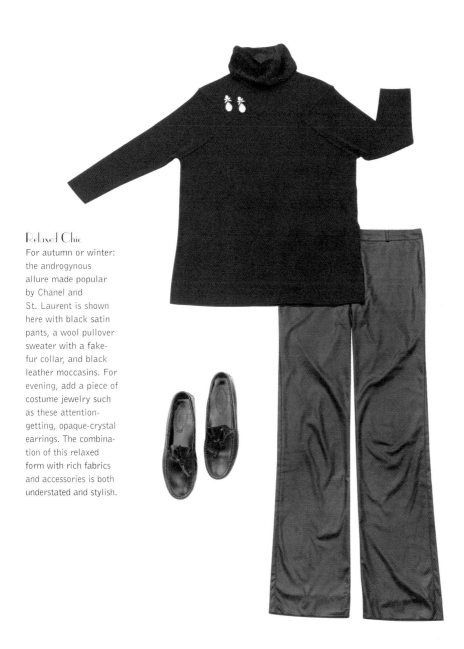

Relaxed Chic

For autumn or winter: the androgynous allure made popular by Chanel and St. Laurent is shown here with black satin pants, a wool pullover sweater with a fake-fur collar, and black leather moccasins. For evening, add a piece of costume jewelry such as these attention-getting, opaque-crystal earrings. The combination of this relaxed form with rich fabrics and accessories is both understated and stylish.

Earth Tones

An elegant spring
outfit, this ensemble
in shades of brown
features a suede jacket
and a camel-colored
turtleneck over wide-
legged, gabardine
pants. Interest is
added with a snake-
skin belt and a car-
nelian necklace in
complimentary tones
of brown and orange.

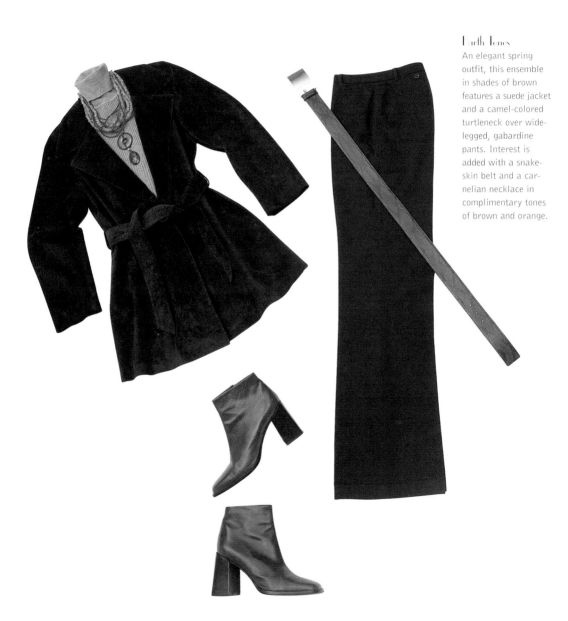

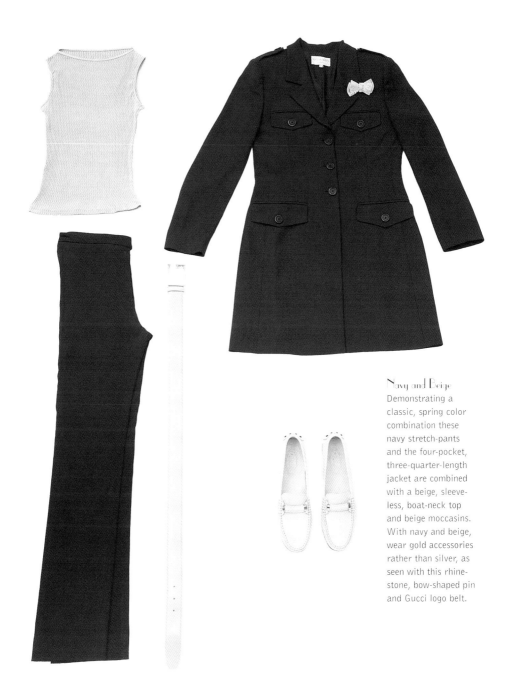

Navy and Beige

Demonstrating a classic, spring color combination these navy stretch-pants and the four-pocket, three-quarter-length jacket are combined with a beige, sleeveless, boat-neck top and beige moccasins. With navy and beige, wear gold accessories rather than silver, as seen with this rhinestone, bow-shaped pin and Gucci logo belt.

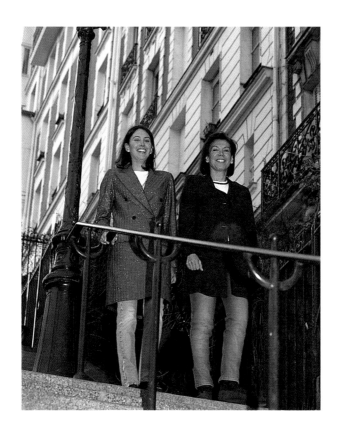

WEEKEND CASUAL

On the weekend, the Parisian woman turns to the classic, casual look of jeans. But don't be deceived, this look is just as calculated as any other. The jeans are never simply an old, comfortable pair but are always impeccably up to date and made of the newest fabrics and colors. Always conscious of her figure, she will match her jeans with a body-hugging Petit Bateau T-shirt and a smart little jacket—the oversized sweater so popular in America is generally avoided. She complements the look with a belt, pretty scarf, and either moccasins or whatever sneakers happen to be in vogue. Jeans are about as casual as the Parisian woman will get. Sweatsuits are scrupulously designated for sports only. Even then, the fashion-conscious woman probably sticks to those by Lacoste.

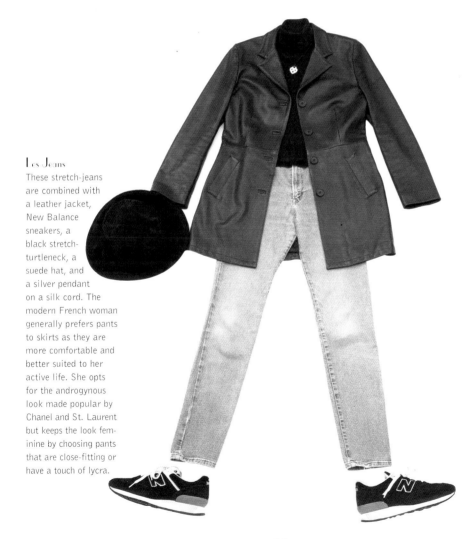

Les Jeans
These stretch-jeans
are combined with
a leather jacket,
New Balance
sneakers, a
black stretch-
turtleneck, a
suede hat, and
a silver pendant
on a silk cord. The
modern French woman
generally prefers pants
to skirts as they are
more comfortable and
better suited to her
active life. She opts
for the androgynous
look made popular by
Chanel and St. Laurent
but keeps the look fem-
inine by choosing pants
that are close-fitting or
have a touch of lycra.

SUMMER

The most dramatic wardrobe variation of the Parisian woman takes place on the few days when the real heat of summer descends upon the city. Almost as though they have been enchanted, Parisian women suddenly begin wearing skimpy dresses and dipping necklines in all shapes and forms as well as colors, flowers, stripes, and transparent fabrics—a moment of anarchy in an atmosphere normally marked by tasteful restraint. Unaccustomed to this jarring change in climate, the Parisian woman is momentarily thrown into a state of confusion and abandons the discipline that usually regulates her everyday wardrobe. Soon enough, however, she finds her bearings and returns to her neutral color combinations and calculated looks—strappy tops with fluid, black pants; navy stretch-pants with white cotton cardigans; and other smart ensembles.

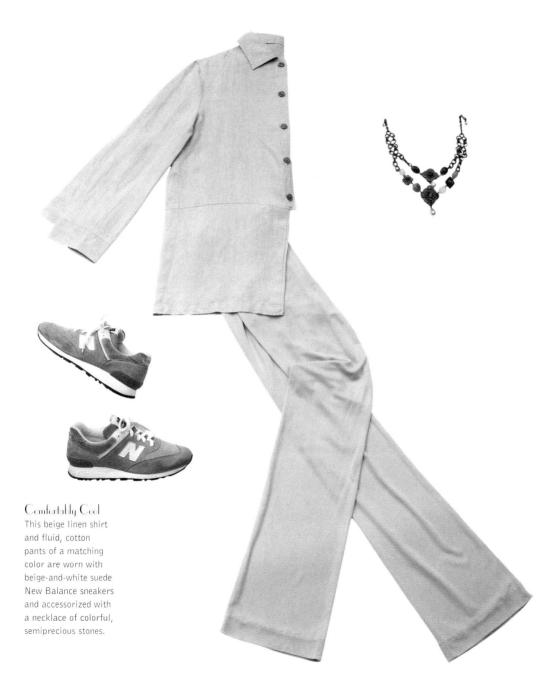

Comfortably Cool

This beige linen shirt
and fluid, cotton
pants of a matching
color are worn with
beige-and-white suede
New Balance sneakers
and accessorized with
a necklace of colorful,
semiprecious stones.

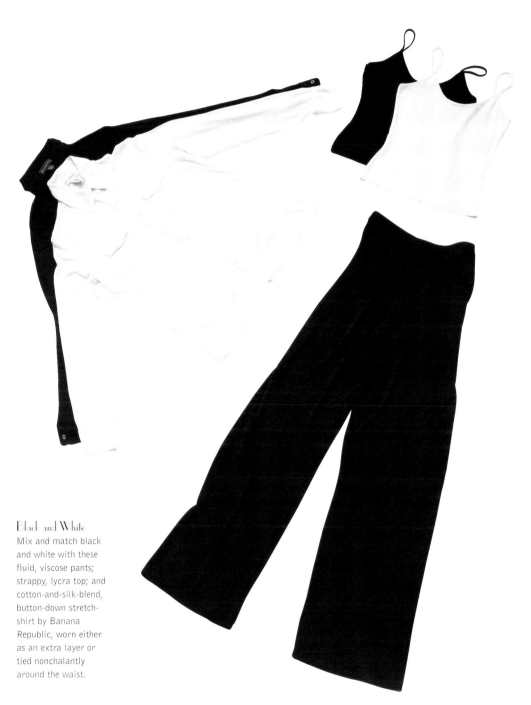

Black and White

Mix and match black and white with these fluid, viscose pants; strappy, lycra top; and cotton-and-silk-blend, button-down stretch-shirt by Banana Republic, worn either as an extra layer or tied nonchalantly around the waist.

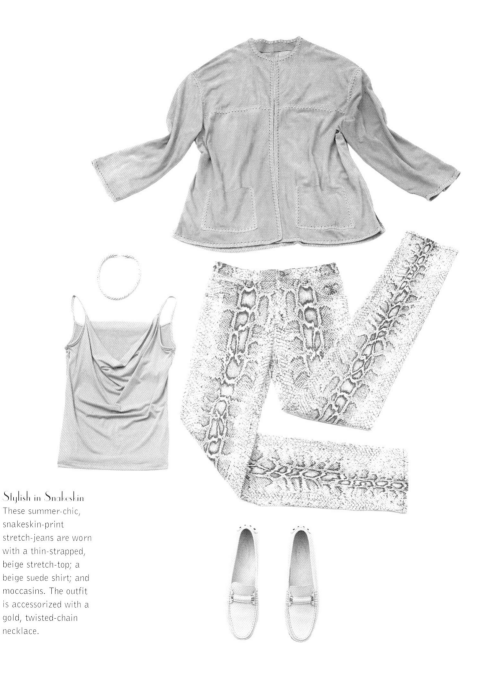

Stylish in Snakeskin

These summer-chic, snakeskin-print stretch-jeans are worn with a thin-strapped, beige stretch-top; a beige suede shirt; and moccasins. The outfit is accessorized with a gold, twisted-chain necklace.

All in White

This summer-perfect, all-white ensemble includes a lingerie-style top with a long, belted, cotton cardigan and straight-legged, white pants. It is accessorized with a costume-pearl and silver necklace.

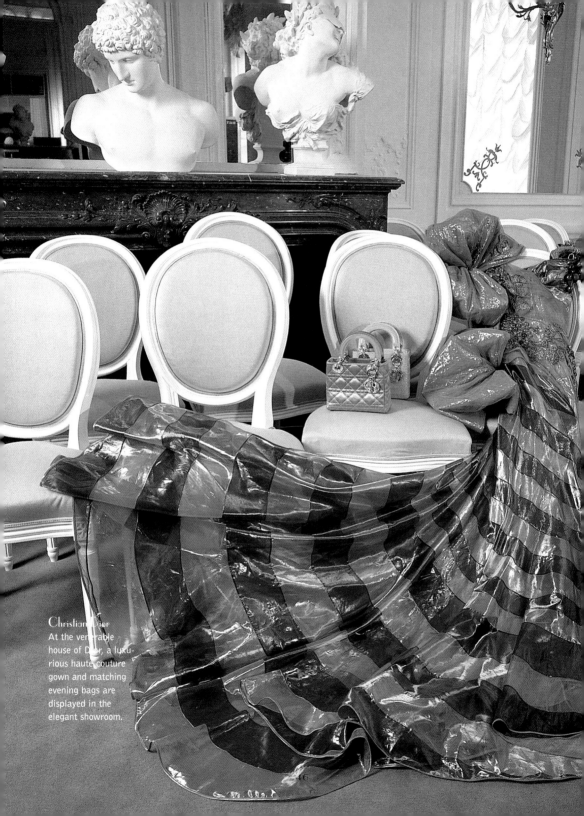

Christian Dior
At the venerable house of Dior, a luxurious haute couture gown and matching evening bags are displayed in the elegant showroom.

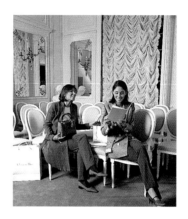

EVENING
Night Glamour

In the evening, the Parisian woman's sense of drama truly shines. Plunging necklines appear as well as bare backs, tight little bustiers, and low-cut jackets daringly worn directly against the skin. Black is still the favorite and is seen in fabrics such as crepe, silk, satin, or velvet. The long evening dress is less versatile than "le smoking," evening suit, as a suit can be mixed and matched with other pieces for another formal occasion, whereas the dress is instantly recognized when worn a second time. However, both suits and dresses continue to be popular, and both are accessorized with prominent costume jewelry. Shoes are usually delicate, with teetering heels up to about three inches high.

FORMAL

For a formal event, the Parisian woman's wardrobe staple is the evening suit with pants, "le smoking pantalon," or an evening suit with a skirt, "le smoking jupe."

Dramatic Color
(left) Varying the color of the jacket and skirt completely alters the overall effect, as seen in the following examples: attention getting in vibrant green and white; ravishing in red and gold

Classic Black
(right) The black evening pants suit is derived from Yves St. Laurent. The suit pictured here has a silk-crepe and wool jacket with satin pants and suede shoes with rhinestone details.

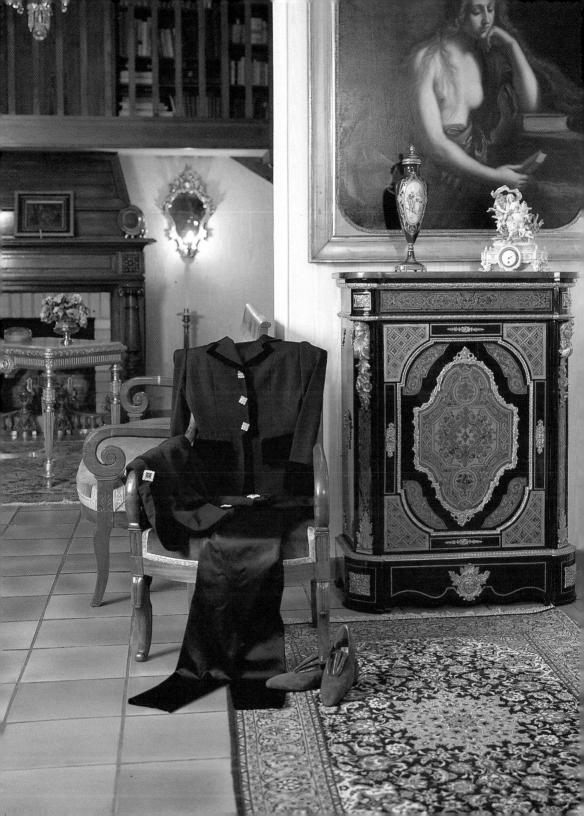

COCKTAILS

In 1926, Coco Chanel revolutionized Paris fashion with the little black dress. As popular at the turn of the century as it was in the 1920s, this style can be appropriate for many occasions, but for cocktails—more elegant than daywear, less formal than black-tie—the little black dress is de rigeur.

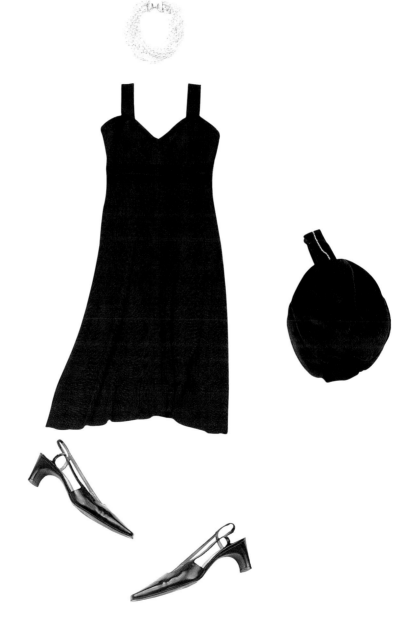

Le Petite Coquette
Sleeveless, cotton-and-silk-blend, black dress with wide straps, accessorized with a twisted rope of pearls and sling-back shoes

While her well-dressed mother finds these looks sophisticated and stylish for cocktails and the elegant soirée, the young Parisian woman looks for something hip when she's off to the clubs.

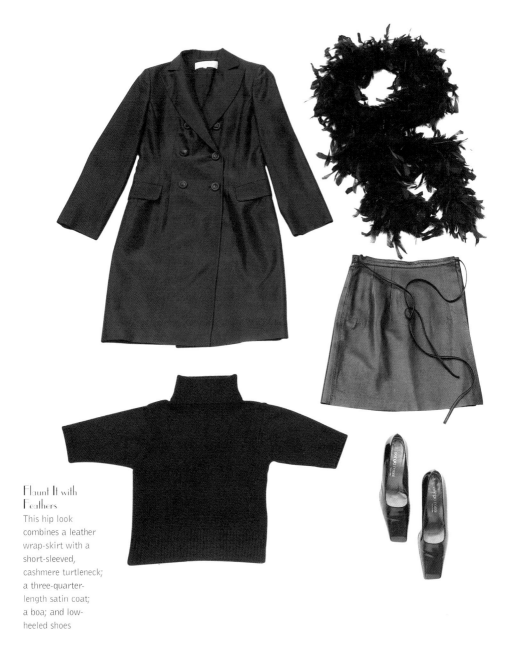

Flaunt It with Feathers

This hip look combines a leather wrap-skirt with a short-sleeved, cashmere turtleneck; a three-quarter-length satin coat; a boa; and low-heeled shoes

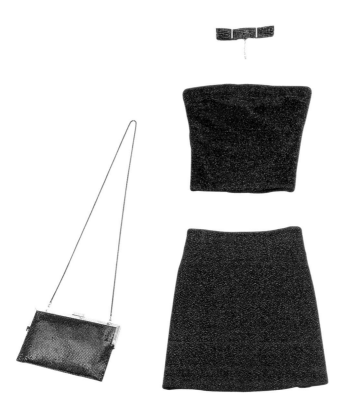

No Frills

A black wool mini-skirt with a subtle sheen and a strapless black bustier set off a jet choker. Heels and a shiny black evening bag finish the outfit.

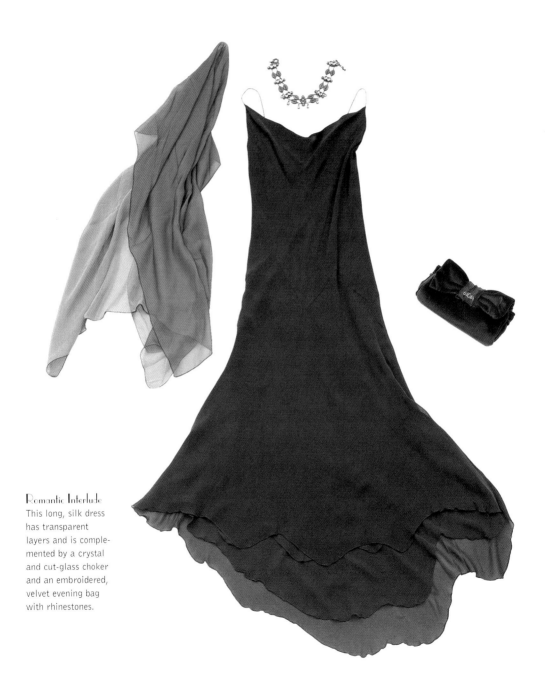

Romantic Interlude
This long, silk dress has transparent layers and is complemented by a crystal and cut-glass choker and an embroidered, velvet evening bag with rhinestones.

Boudoir Glamour
This full-length,
satin slip-dress in
rich brown is simple
yet sexy.

Delicate Allure
The long skirt and
matching top are
fashioned in semi-
transparent silk.
Interest is added by
the top's beaded
straps, which take
the place of jewelry.

BRIDAL
Wedding Style à la Parisienne

Known for ultra-feminine eveningwear inspired by 1940s glamour, Lolita Lempicka is now offering a line of breathtakingly beautiful wedding gowns. At right, the charming storefront of the bridal shop Les Mariées de Lolita features a romantic confection of a dress adorned in lace and feathers. In France it is common to have not one wedding outfit but two—one for the religious ceremony and another for the civil ceremony. At bottom, black-and-white ensembles in the window of Les Folies d'Elodie are perfect for a civil wedding.

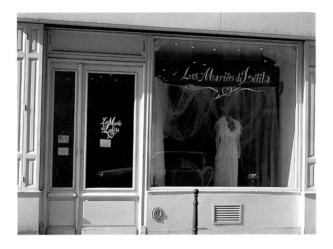

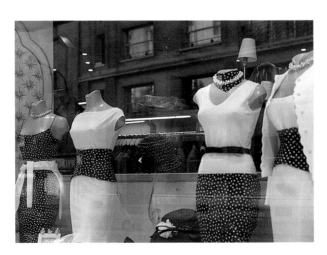

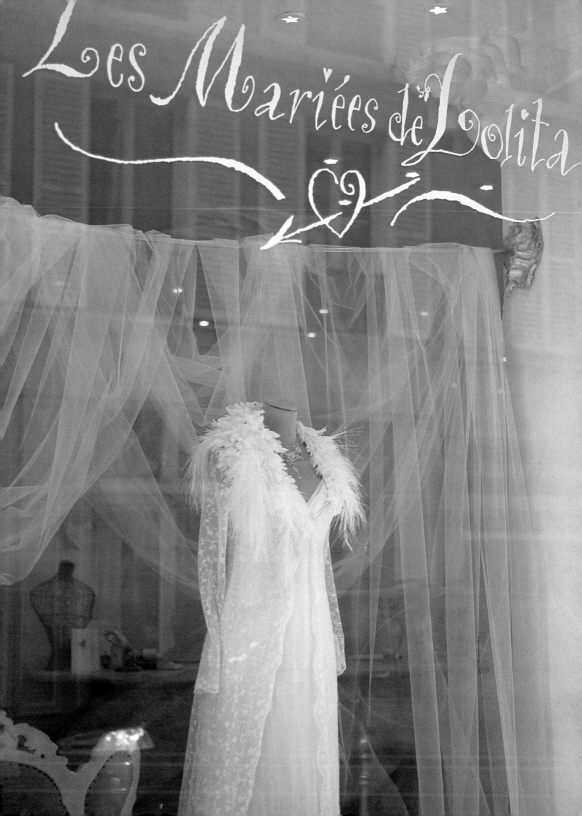

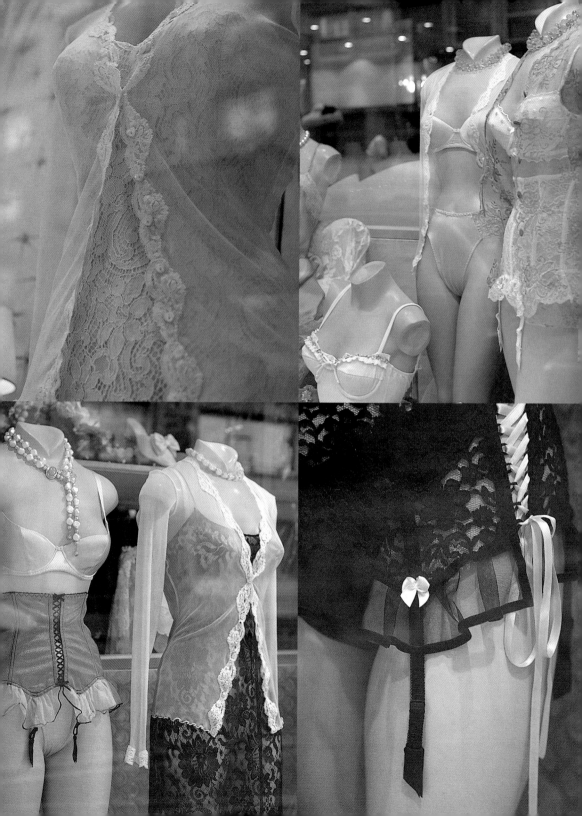

LINGERIE
Quintessential Feminine Allure

In contrast to the Parisian woman's tendency towards restrained elegance, her lingerie collection is pure romance. Preferred lingerie styles include demi-cup bras—most flattering for deep necklines—and thongs or string bikinis to maintain a smooth line under fitted pants or skirts. Marked by elaborate detail and fine fabrics, good-quality French lingerie tends to be fairly expensive. However, it can be broken down in the following categories according to price and style.

• The quintessential name in Parisian lingerie, Christian Dior is the most luxurious–and most expensive.

• Classic, quality lingerie brands in silk, satin, lace, and other fine fabrics include Aubade, Lise Charmel, Simone Perele, Rosy, Chantelle, LeJaby, and Barbara.

• Less expensive—but equally feminine—brands, mostly in cotton, for younger women include Princesse Tam Tam, Etam, Ci Dessous, and DIM.

• Brands which offer noteworthy lingerie designs in addition to their other lines of products are Erès, Capucine Puerari, and Cacharel.

Les Folies d'Elodie
(left) Irresistible details from the window display of Les Folies d'Elodie, a favorite boutique in the 16th arrondissement that offers handmade pieces in luxurious fabrics.

History of French Lingerie

1800

A woman's lingerie consists of a shirt, corset, and underskirt. Created for her trousseau, these pieces are monogrammed with her initials in preparation for her marriage. By the end of the century, the underskirt is replaced by knickers or culottes.

1900

Hermine Cadole creates an all-in-one bra and corset.

1910

Paul Poiret's modern clothing designs briefly liberate women from the corset.

1920

Because women are becoming more active in sports and dance, a corset without rigid bones is introduced. Petit Bateau presents cotton-jersey underpants, replacing the old-fashioned culottes.

1930

Appearance of the elastic corset and the silk girdle with elastic lace. Introduction of pajamas for women.

1940

With Dior's wasp-waisted New Look, the return of the lace-up corset.

1950

Appearance of the all-in-one bra and girdle. Lycra appears and LeJaby presents the underwire bra.

1960

Introduction of the bra without wire support.

1970

Lagging interest in feminine lingerie. The man's pajama becomes popular for women.

1980

Return of wire supports and detailed workmanship in lace by designers such as Chantal Thomass. Jean-Paul Gaultier presents a runway show of his lingerie.

1990

The age of the Wonderbra!

Use of new stretch materials such as microfiber give new meaning to body shaping. Thanks to transparent fabrics, details of lingerie are seen through a woman's outer clothes–lace peeking from beneath a suit jacket, as demonstrated by Chloe, or a slip showing through a seductive evening dresses, as seen with Lolita Lempicka.

The return of the corset in designs by Alaïa, Mugler, Dior, Givenchy, Gaultier, and Lacroix— at the close of the millennium, a nostalgic nod to past ideals of feminine allure.

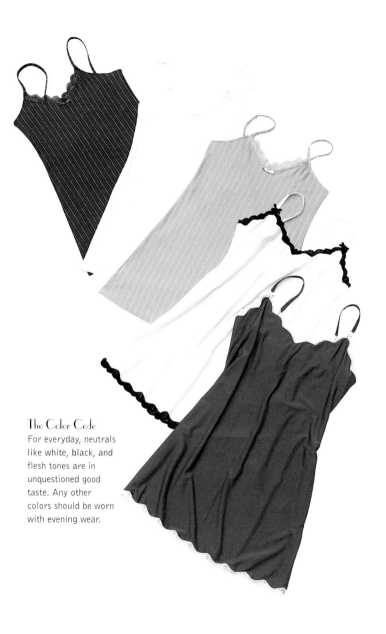

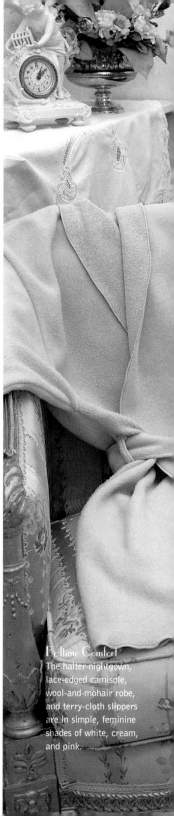

The Color Code

For everyday, neutrals like white, black, and flesh tones are in unquestioned good taste. Any other colors should be worn with evening wear.

Bedtime Comfort

The halter-nightgown, lace-edged camisole, wool-and-mohair robe, and terry-cloth slippers are in simple, feminine shades of white, cream, and pink.

BATHING SUITS
Classic Swimwear

The Parisian woman on the beach is instantly recognizable by her simple, classic bathing suit. The best examples of this sophisticated elegance are seen at Erès, a longtime, favorite boutique for quality beach-wear—a few of the sleek but sexy models from their window display are seen here below and at right. The young Parisian, however, will admit she is far from faithful to such restrained simplicity. Once she has arrived at her vacation destination—whether it be the Caribbean or the Côte d'Azur—she often finds her suit dramatically more conservative than those around her and soon runs out to purchase a new, more colorful one from a local shop.

On Color Choice

It is easy to spot the Parisian woman by the color of her suit. The first days of her vacation she consistently wears black. By the last day, she is tanned and relaxed—and you'll find her in white.

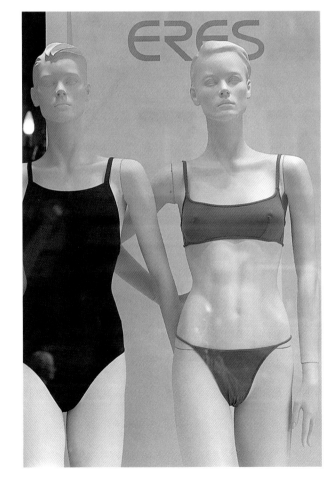

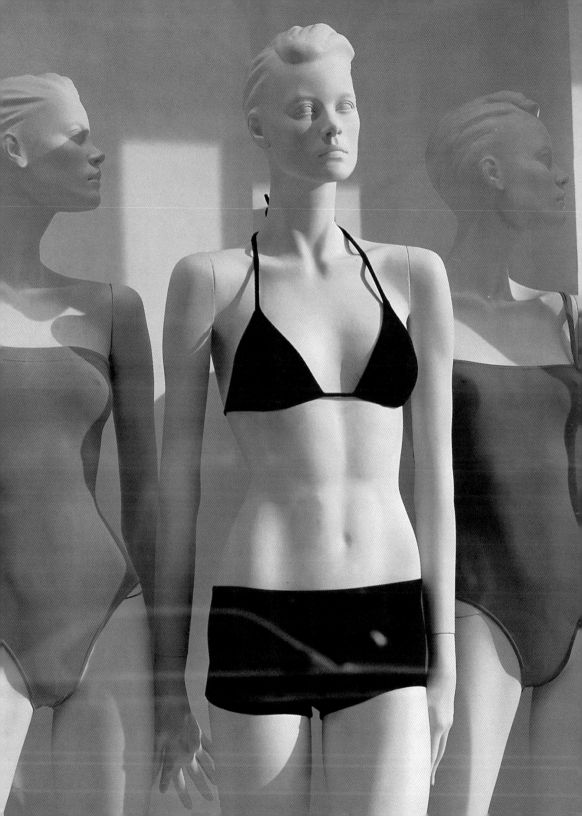

THE COAT
Outerwear for Autumn through Spring

The following basic coats and jackets will take you from day to night throughout the year. •Wool coat, full-length or short, shown below and at right. •Down coat, full-length or short. •Leather jacket or coat in any of the following styles: short and fitted, aviator, three-quarter-length, or full-length, as worn by Viriginie on page 69. •For evening, a full-length coat of a formal fabric such as velvet—seen on page 68 with a red crushed-velvet scarf and gloves and velvet bag.

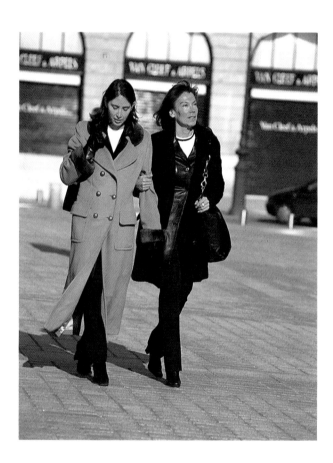

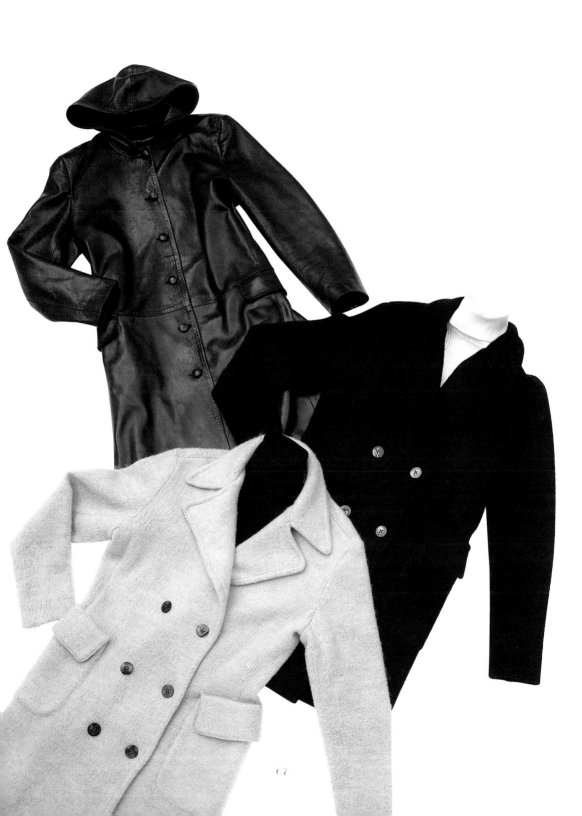

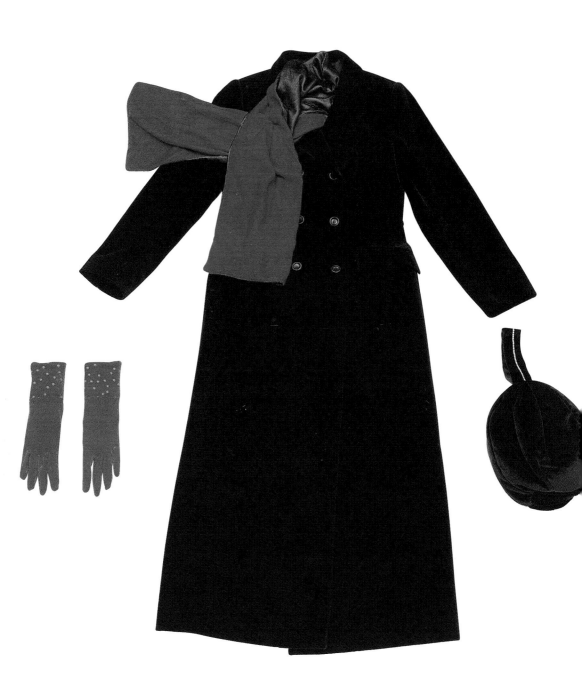

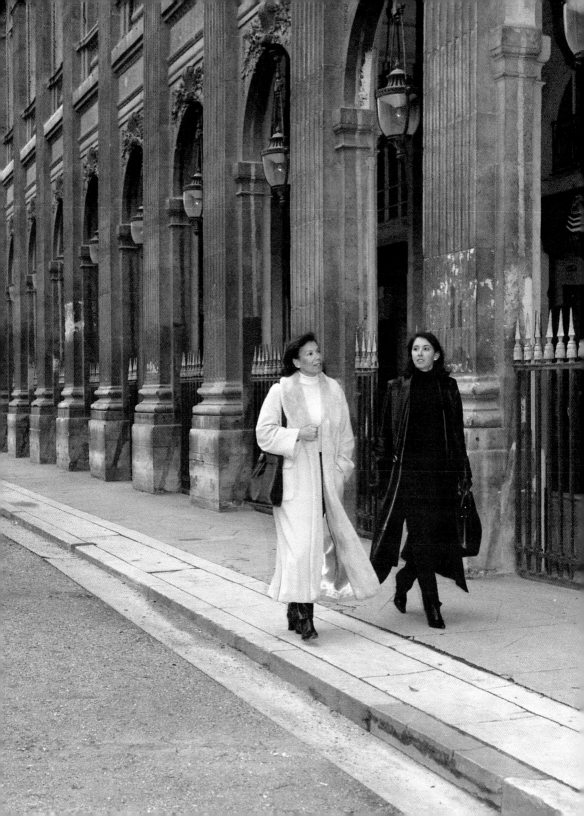

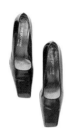

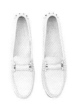

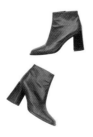

ACCESSORIES

Personal Flair

No matter how
stylish, an outfit
remains incomplete
without the proper
accessories.
Set off by simple,
understated
clothes, accessories
offer a finishing
touch, allowing
one to bestow a
classic outfit with
personal flair.

ACCESSORIES
Finishing Touches

While a solid wardrobe acts as the base, accessories like shoes, bags, belts, and scarves are essential details. The choice of an elegant, low-heeled shoe versus a strappy sandal, for example, can set the tone of an ensemble, transforming a simple suit or dress from daywear into eveningwear. Similarly, the basic bag must complement the outfit whatever the occasion—it is crucial that the bag be versatile and always in good taste.

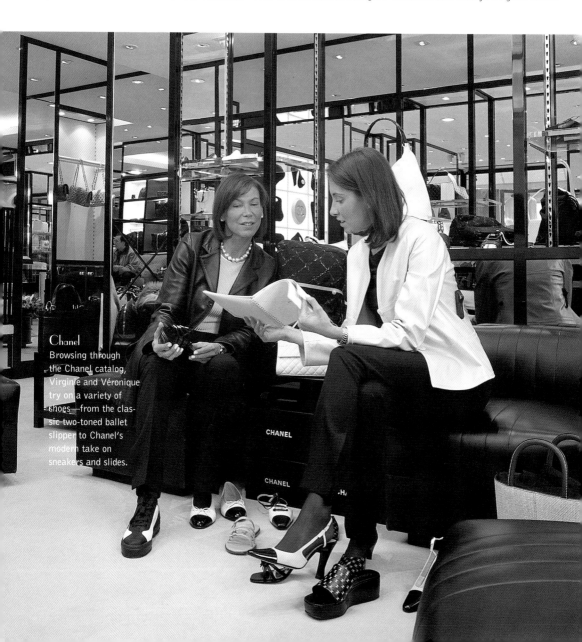

Chanel
Browsing through the Chanel catalog, Virginie and Véronique try on a variety of shoes—from the classic two-toned ballet slipper to Chanel's modern take on sneakers and slides.

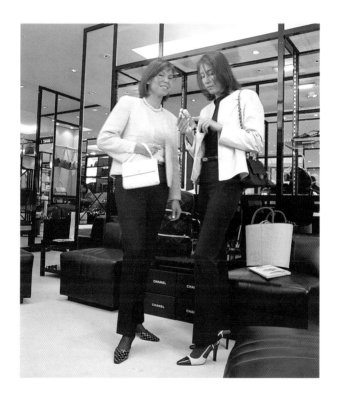

Chanel

At the Chanel bou-
tique, Virginie and
Véronique show off
their choice of acces-
sories: black-and-
white heels, classic
quilted bags, and
black leather belts
with buckles in silver
and gold.

SHOES
From Fancy Footwear to Casual Comfort

HEELS
An elegant shoe offers a simple solution to dressing up an outfit for evening. At right is a sampling of delicate mules and strappy sandals by Sergio Rossi and Stéphane Kélian. For the young Parisian out on the town, some more audacious looks in show-stopping gold (page 76) and pearly white (below) by Freelance.

BOOTS
The high-heeled boot is appropriate in many incarnations, as seen on page 77: in leather or suede, square or pointed toe. Always with an eye toward versatility, black remains the color of choice. It is very rare, even in winter, that the Parisian woman wears a heavy shoe or snow boot, even if her feet are freezing. On the other hand, platform heels—a style that offers the same height as traditional heels while allowing for more comfort—have become increasingly popular. Some particularly trendy women even go so far as to wear decidedly un-French Timberlands.

SNEAKERS
Sneakers, or "les Basket" as they are called, have become an indispensable item and are now adopted by mother and daughter alike. Unmatched in comfort, the right styles can present a look of relaxed chic all year round. However, don't expect to see the Parisian woman in running shoes, cross trainers, or other such high-tech models designed for wear in serious sports. Rather, she opts for a more playful, trendy look such as black or tan suede New Balance sneakers or even—budget permitting—cutting-edge styles by high-end designers like Armani, Hermès and Chanel.

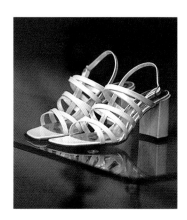

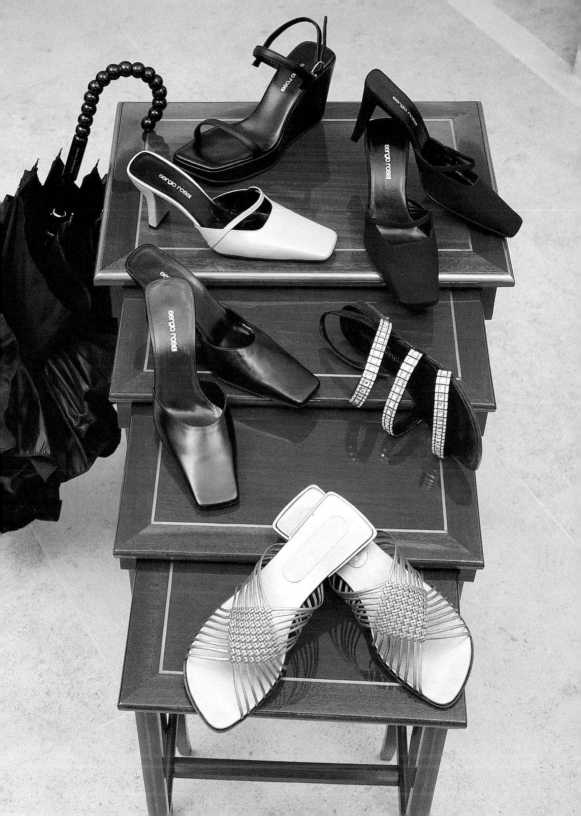

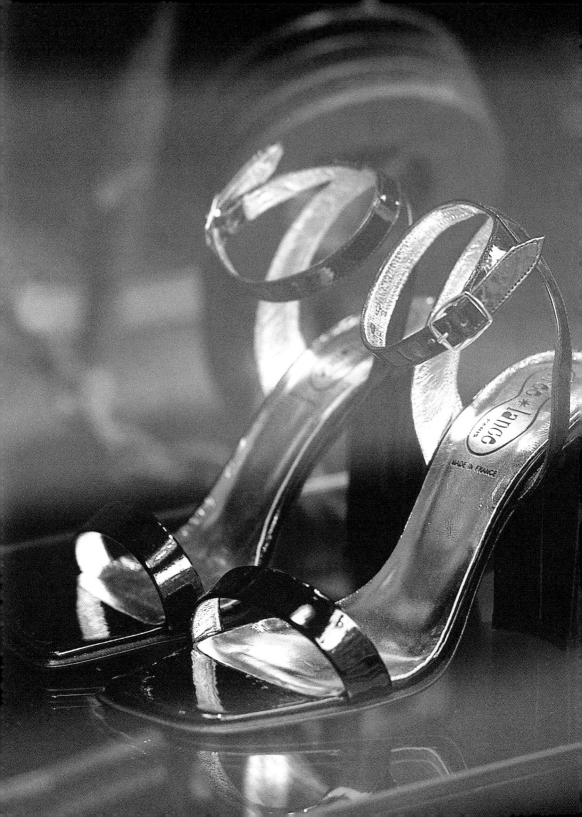

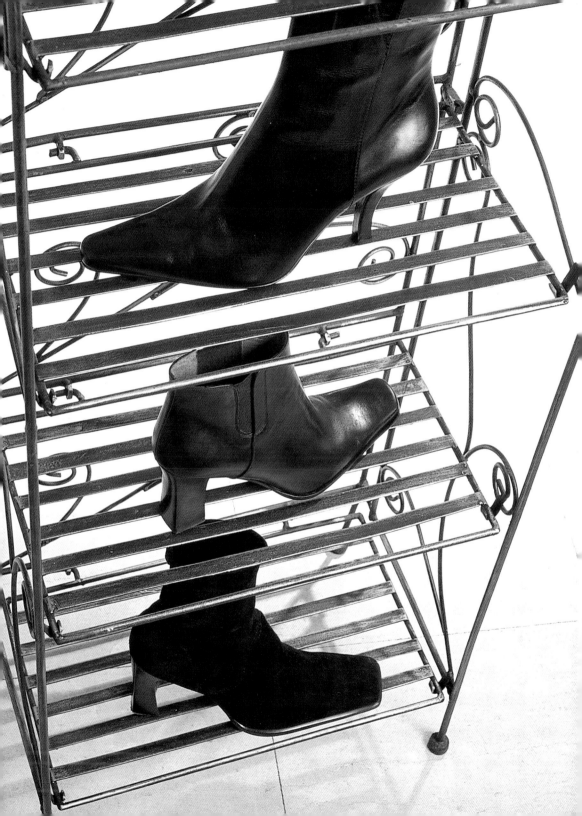

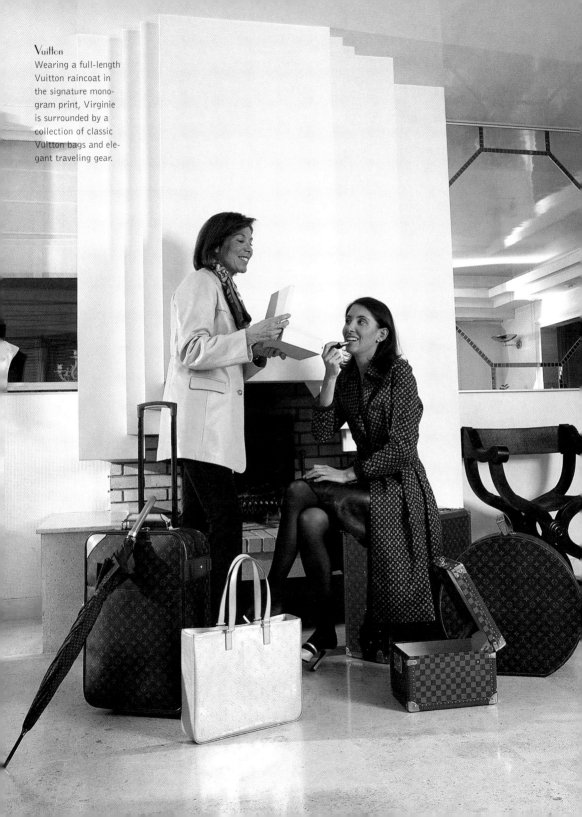

Vuitton
Wearing a full-length Vuitton raincoat in the signature monogram print, Virginie is surrounded by a collection of classic Vuitton bags and elegant traveling gear.

THE BAG
Practical Elegance

A mark of one's signature style, the bag is an accessory of primary importance. The handbag or shoulder bag should be simple and functional as well as smart, elegant, and timeless. According to what is in vogue, the preferred bag might bear the label of such perennial accessory leaders as Dior, Hèrmes, Chanel or Vuitton. Classic leather bags such as Longchamps, Lancel, Didier Lamarthe, and Gampel are always stylish and appropriate. Rather than follow every new trend in form and fabric, the Parisian woman generally returns to the same classic model of bag that she can count on as a product of quality and mark of good taste. Chosen with strict attention to detail, the bag is an investment in long-term style, a centerpiece within her wardrobe for years to come.

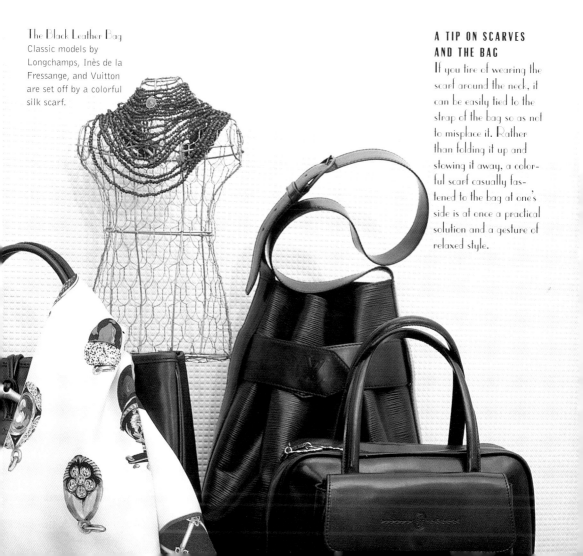

The Black Leather Bag
Classic models by Longchamps, Inès de la Fressange, and Vuitton are set off by a colorful silk scarf.

A TIP ON SCARVES AND THE BAG
If you tire of wearing the scarf around the neck, it can be easily tied to the strap of the bag so as not to misplace it. Rather than folding it up and stowing it away, a colorful scarf casually fastened to the bag at one's side is at once a practical solution and a gesture of relaxed style.

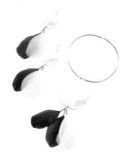

JEWELRY

Transformative

Jewelry adds
versatility as well
as an elegant
finishing touch to
any outfit. The
Parisian woman
usually wears
understated jewelry
during the day,
but at night
she expresses her
sense of glamour
with dramatic,
statement-making
pieces.

JEWELRY
The Fundamentals

The Parisian woman's everyday jewelry is generally very discreet. This is not to say that she does not wish her jewelry to be noticed. On the contrary, her basic pieces, however modest in size or form, must be instantly distinguishable as classic brands and therefore in good taste.

Her most fundamental pieces are a simple gold chain and bracelet, as well as a substantial watch. Some of her favorite watches over the past few decades have been from Cartier, Chanel, and Rolex in the 1970s; Poiray or Perrin in the 1980s; and Boucheron, Chaumet, or Cartier in the 1990s—particularly popular in steel or white gold. Her collection also likely includes:

• Colored stone or pearl rings, such as the classic models by Chanel.

• A simple pendant on a chain or silk cord—Perrin's heart-shaped pendant, for example, which is very much in style today.

• The basic string of pearls—this was briefly abandoned but is now in vogue in a shorter length, with larger, gray pearls rather than the perennial white. Some popular styles are by Chanel and Tecla.

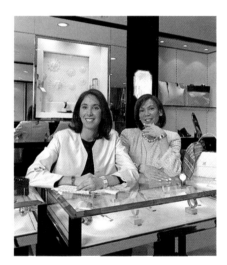

How to Choose?
Virginie and Véronique sport elegant watches—one on each wrist—at the Chanel jewelry counter.

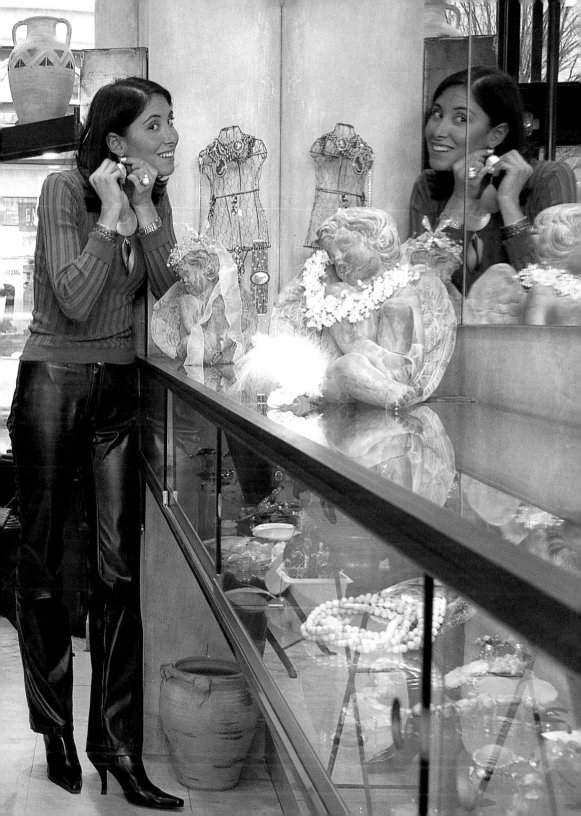

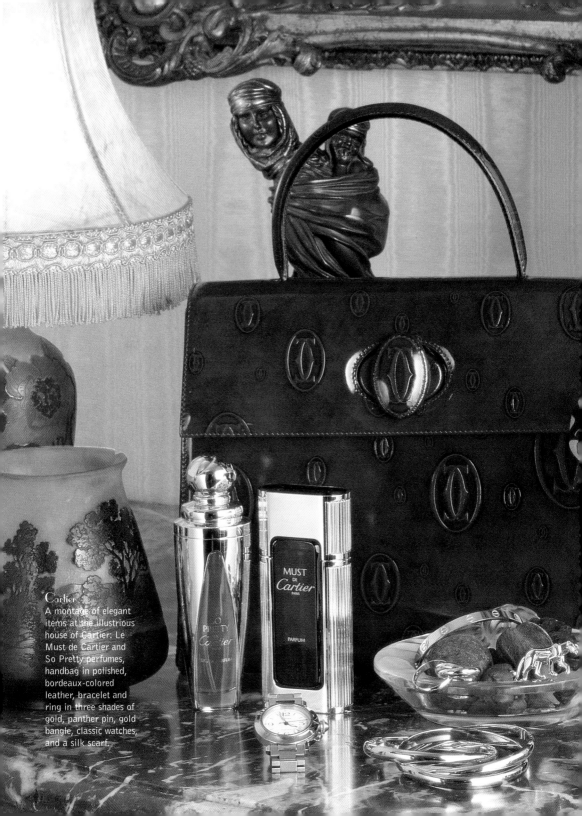

Cartier
A montage of elegant
items at the illustrious
house of Cartier: Le
Must de Cartier and
So Pretty perfumes,
handbag in polished,
bordeaux-colored
leather, bracelet and
ring in three shades of
gold, panther pin, gold
bangle, classic watches,
and a silk scarf.

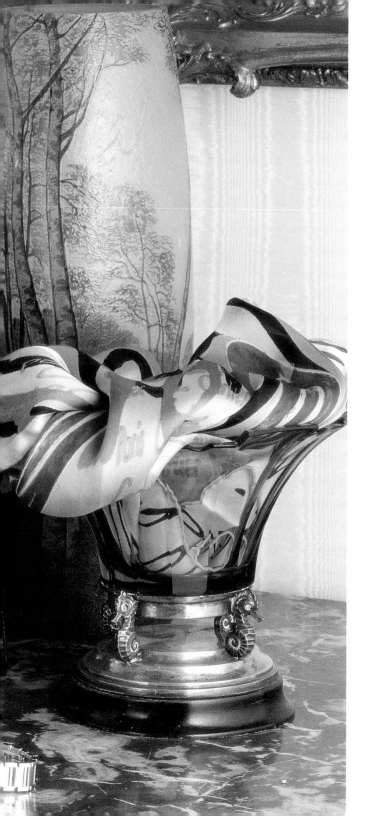

SELECTION OF PIECES

Wearing an entire set of jewelry at once usually overwhelms an outfit. Rather, choose select pieces to enhance your clothing. Wear just the earrings and brooch, for example, or the necklace and bracelet.

SILVER OR GOLD

Silver is most flattering when matched with cool tones such as black and gray. Similarly, gold is best worn with warm tones such as brown and beige.

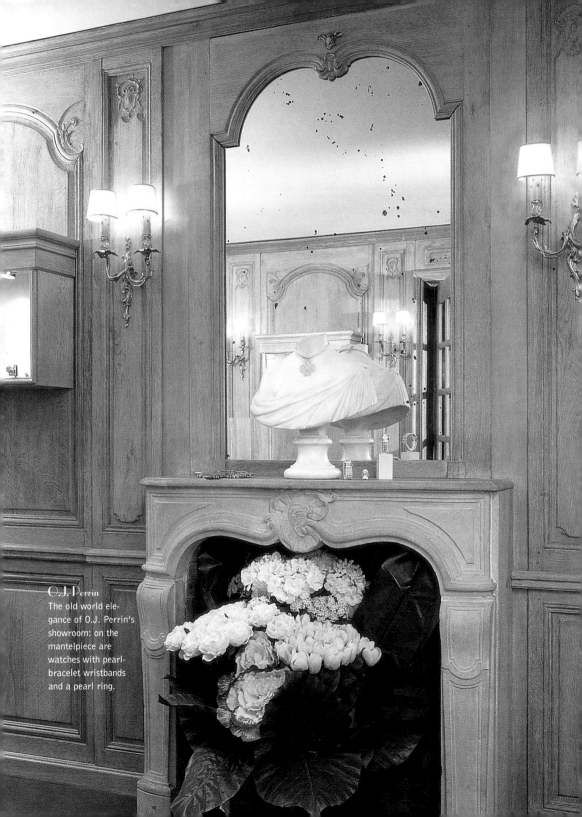

O.J. Perrin
The old world elegance of O.J. Perrin's showroom: on the mantelpiece are watches with pearl-bracelet wristbands and a pearl ring.

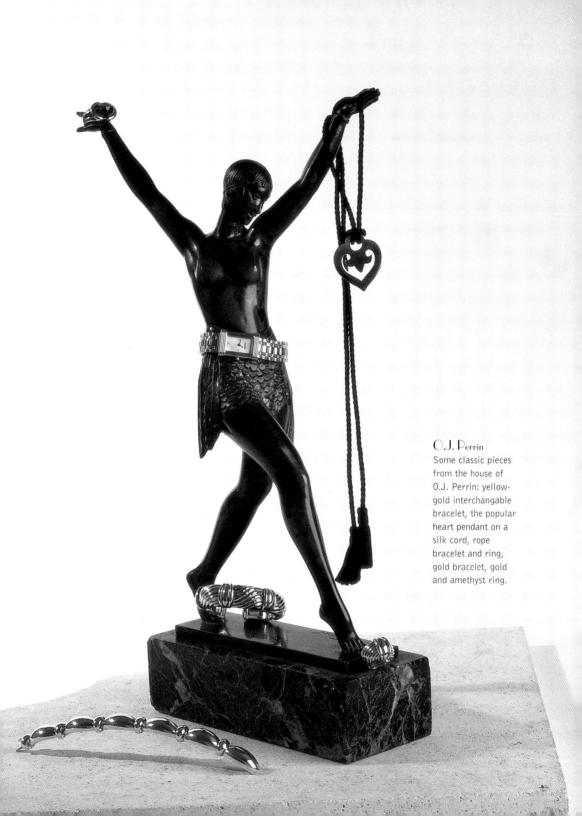

O.J. Perrin

Some classic pieces
from the house of
O.J. Perrin: yellow-
gold interchangable
bracelet, the popular
heart pendant on a
silk cord, rope
bracelet and ring,
gold bracelet, gold
and amethyst ring.

COSTUME JEWELRY
Making a Statement

However restrained during the day, *la Parisienne* must dazzle at night. When dressing up for cocktails or a gala event, the Parisian woman looks to the *bijou de createur*, "designer costume piece," that will set her apart from the crowd. These pieces are not shy—bold in form and material, they convey a strong sense of personal style. Adding a single, eye-catching piece of jewelry to an outfit is often enough to transform a sober daytime look into evening allure.

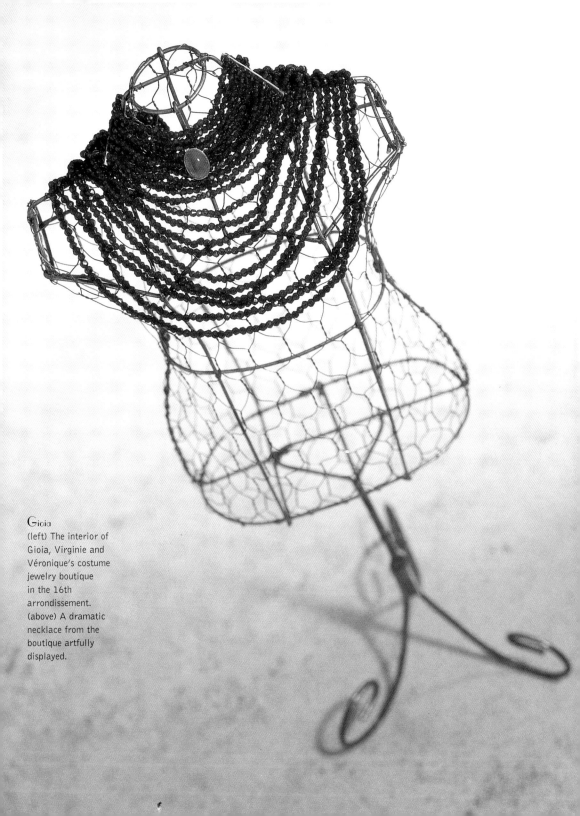

Gioia
(left) The interior of
Gioia, Virginie and
Véronique's costume
jewelry boutique
in the 16th
arrondissement.
(above) A dramatic
necklace from the
boutique artfully
displayed.

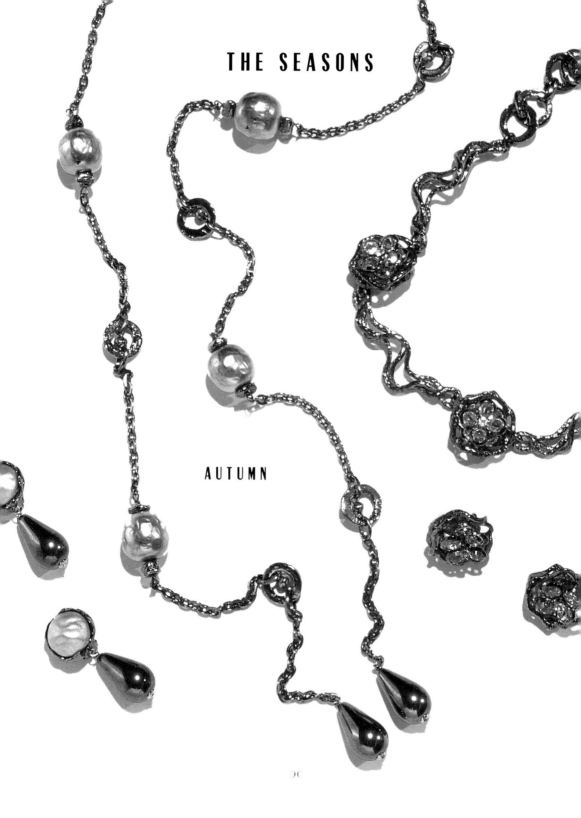

THE SEASONS

AUTUMN

Left:

A long, costume-pearl necklace—shown with matching earrings—to be worn tied in a knot, or a short necklace with crystal flowers and matching earrings would be attractive with a simple gray suit. The combination of a classic suit with designer pieces such as these creates a couture effect. A suit worn with gold is more classic, whereas the same suit worn with jewelry in tones of silver and gray is at once elegant and modern.

Right:

These necklaces would be flattering with an ensemble in autumn shades of brown: couture necklace of venetian-style iridescent crystals set in copper and a matching bracelet and earrings; short, topaz-colored, glass-bead necklace.

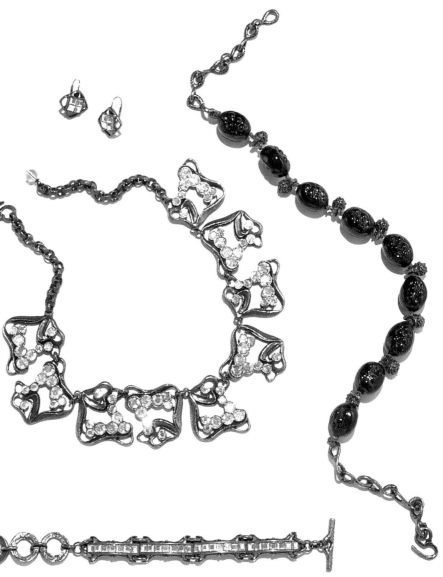

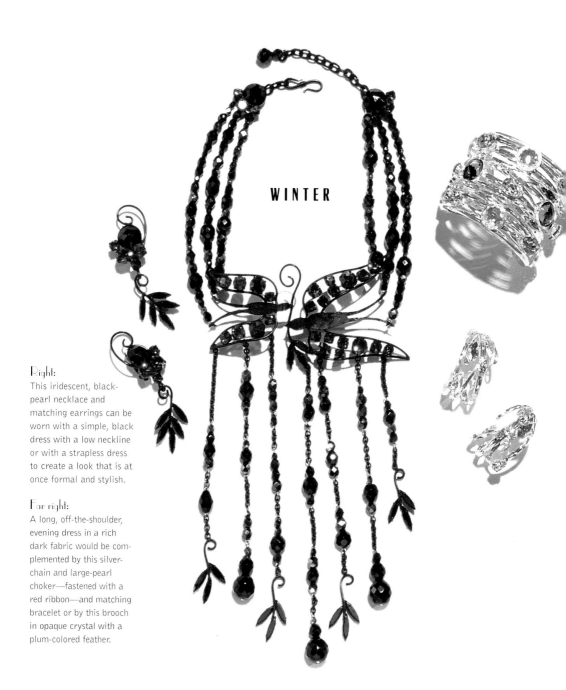

WINTER

Right:
This iridescent, black-pearl necklace and matching earrings can be worn with a simple, black dress with a low neckline or with a strapless dress to create a look that is at once formal and stylish.

Far right:
A long, off-the-shoulder, evening dress in a rich dark fabric would be complemented by this silver-chain and large-pearl choker—fastened with a red ribbon—and matching bracelet or by this brooch in opaque crystal with a plum-colored feather.

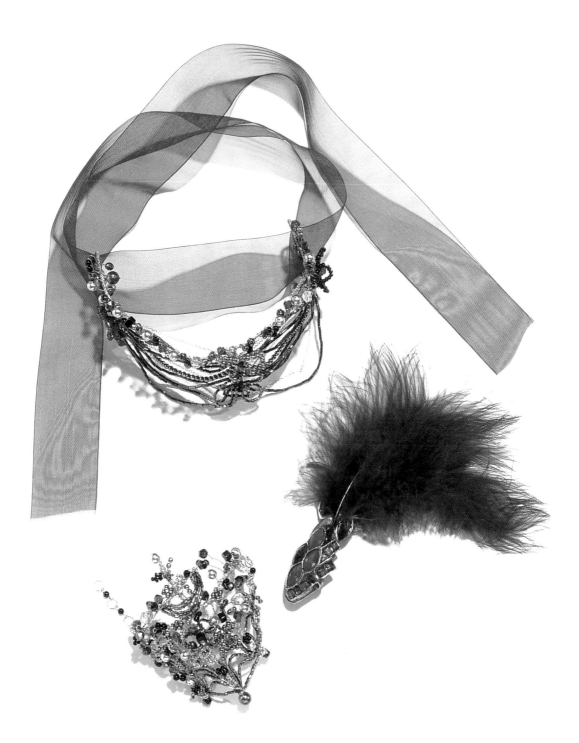

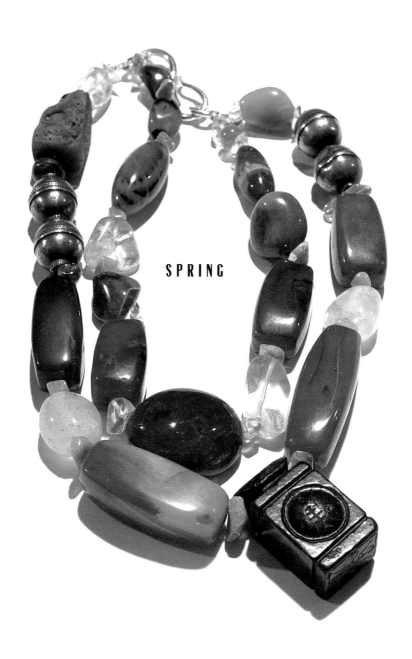

SPRING

Below:
This necklace with a large, mother-of-pearl disk on a silver wire, with feathers in shades of red, white, and brown might be worn with a spring ensemble in chestnut-brown suede.

Left:
Show this dramatic necklace, made with semi-precious stones, to its best advantage against linen or suede in natural tones.

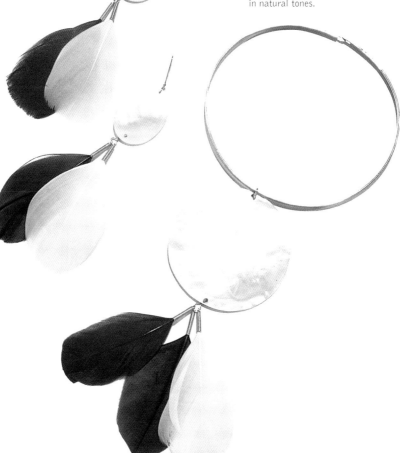

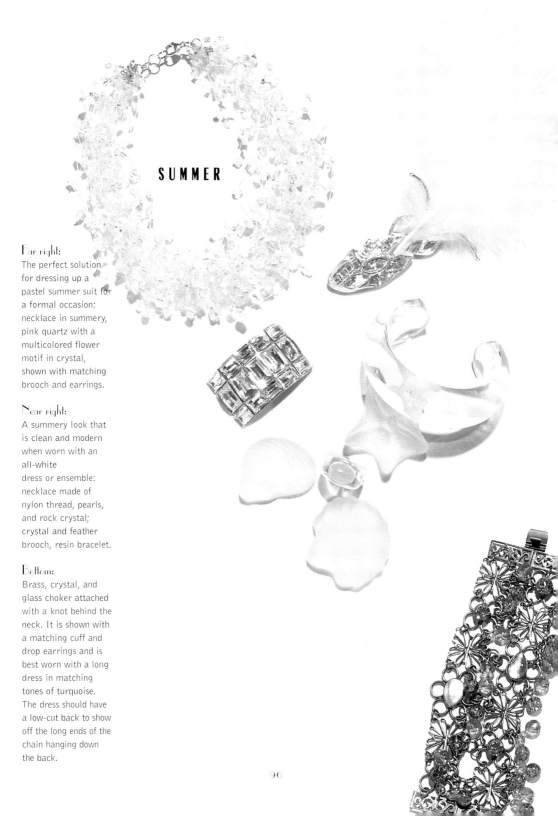

SUMMER

Far right:
The perfect solution
for dressing up a
pastel summer suit for
a formal occasion:
necklace in summery,
pink quartz with a
multicolored flower
motif in crystal,
shown with matching
brooch and earrings.

Near right:
A summery look that
is clean and modern
when worn with an
all-white
dress or ensemble:
necklace made of
nylon thread, pearls,
and rock crystal;
crystal and feather
brooch, resin bracelet.

Bottom:
Brass, crystal, and
glass choker attached
with a knot behind the
neck. It is shown with
a matching cuff and
drop earrings and is
best worn with a long
dress in matching
tones of turquoise.
The dress should have
a low-cut back to show
off the long ends of the
chain hanging down
the back.

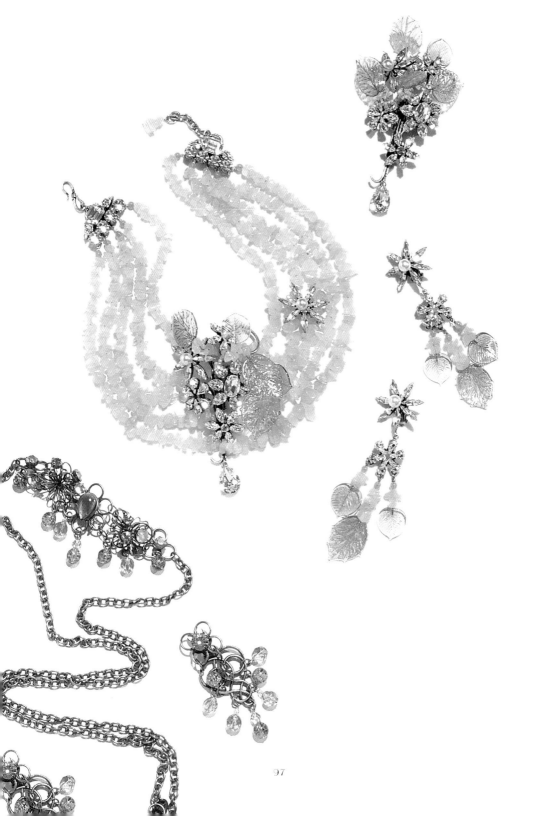

PERFUME

A Parisian Tradition

Synonymous with
romance and feminine
allure, perfume
remains an indispens-
able element of
Parisian style.

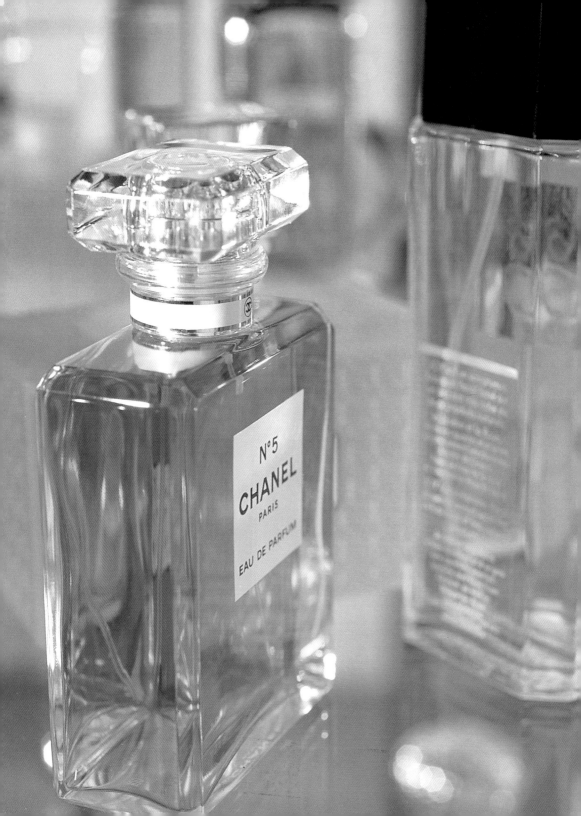

PERFUME
Nostalgic Romance

Unlike their grandmothers, who often wore a single fragrance throughout their entire lives, modern Parisian women tend to switch perfumes from season to season. So, today, a fragrance often evokes memories of a particular period in a woman's life and becomes not just a transient element of personal style but an object of long-time, sentimental value. It is hardly surprising, then, that the Parisian woman's collection of perfumes is extremely important to her, and that the gift of a classic perfume is as cherished as an elegant wristwatch or a string of pearls.

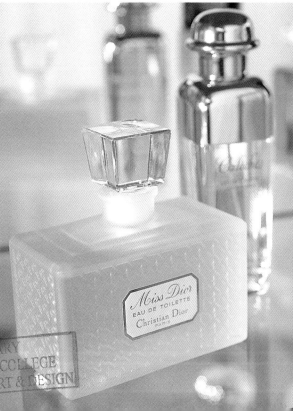

Fragrances Past and Present

Classics

There are several legendary perfumes that have long been emblems of luxury and continue to embody the spirit of femininity today. The identity associated with each scent is as seductive as ever and will remain irreplaceable in the Parisian woman's life. Such fragrances include:

Opium by Saint Laurent
Nº5 by Chanel
Cabochard by Grès
Joy by Jean Patou
Calèche by Hermès
Shalimar by Guerlain
Miss Dior by Christian Dior
L'Air du Temps by Nina Ricci
Je Reviens by Worth
Eau de Roche by Rochas
Le Must by Cartier
Boucheron by Boucheron

Fresh and Light for Summer

Cabotine by Grès
Les Jardins de Bagatelle by Guerlain
Le Petit Guerlain by Guerlain
Eau de Rochas by Rochas
Narcisse by Chlöe
Cristalle by Chanel

Heavier and Full-bodied for Winter

Quartz by Molyneux
Habanita by Molinard
L'Heure Bleue by Guerlain
Shalimar by Guerlain

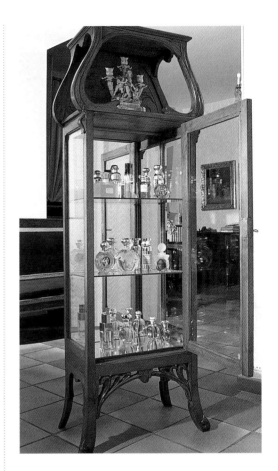

Modern Classics

Some of the Parisian woman's favorite new fragrances are by L'Artisan Parfumeur, Annick Goutal, and Octée. Each of these noteworthy, independent perfume houses boasts its own not-to-be-missed Paris boutique.

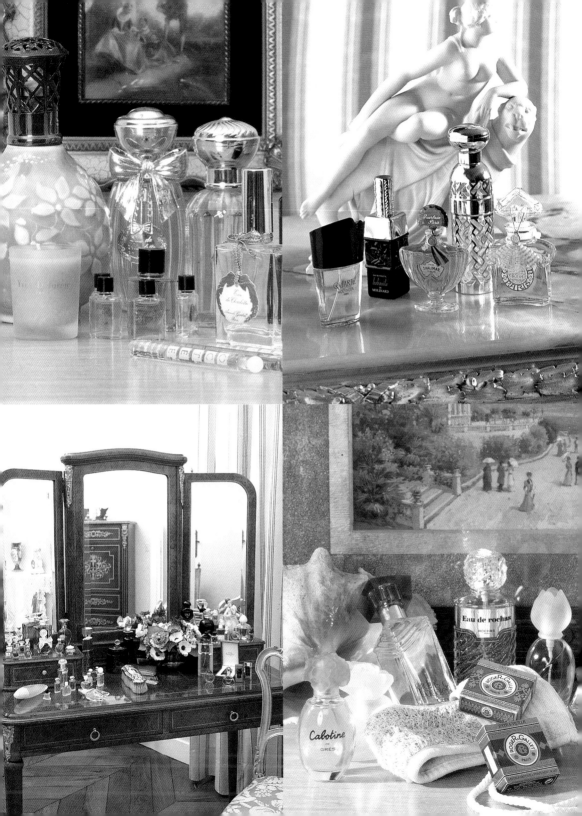

Jean Patou

In defiance of the Great Depression, Patou launched Joy in 1930 to symbolize the joy of living. A scent of extraordinary intensity, it takes 10,600 jasmine flowers and 28-dozen May roses to create a single ounce. At right, a fragrance display from Jean Patou's Art Deco boutique near the Place de de la Concorde features Joy in its renowned crystal Baccarat bottle. The twelve small bottles lined up on the lower shelf contain Patou's collection of historic, symbolic fragrances that were reissued in 1984 under the title Ma Collection.

1925 Amour, Amour, Que Sais-Je?, and Adieu Sagesse (A trinity of fragrances representing three moments in the development of love.)

1927 Chaldée

1929 Moment Supréme

1930 Cocktail

1933 Divine Folie

1935 Normandie (In honor of the maiden voyage of the ocean liner Normandie from France to New York.)

1936 Vacences (The year France established paid holidays for all workers.)

1938 Colony (Inspired by the French Colonial Exposition in 1937.)

1946 L'Heure Attendue (Created in celebration of the liberation of France.)

1964 Céline (Perfumes that have stood the test of time—and temperature.)

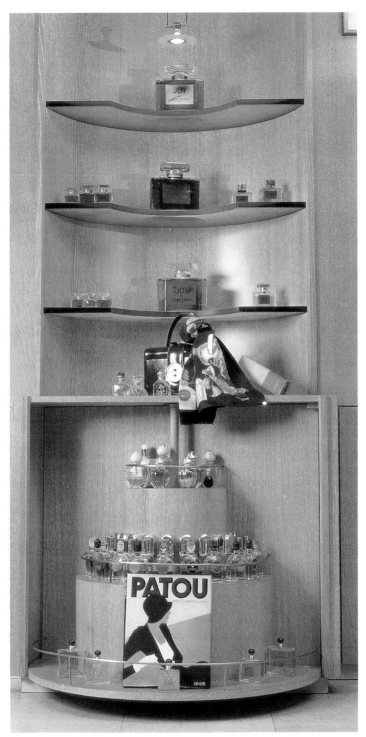

History of French Perfume

1828 Guerlain is founded by Pierre-Francois-Pascal Guerlain on the rue de Rivoli.

1853 Guerlain is named the official *parfumeur* of His Majesty, Charles X.

1849 Foundation of Molinard in Grasse. Their first Paris boutique opens in 1920, followed by the debut, in 1921, of the perfume Habanita, their greatest success.

1889 Presented at the Universal Exposition of 1889, Jicky by Guerlain marks the beginning of the modern era of perfume.

1904 The perfume house of Coty is established with their first success, La Rose Jacqueminot. Coty revolutionizes perfume presentation—they collaborate with Baccarat and Lalique to create precious, beautiful bottles.

1911 Paul Poiret is the first couturier to launch his own perfumes under the group name Les Parfums de Rosine. Each perfume in the series is associated with one of his dress designs and packaged as a work of art.

1921 Chanel Nº5 is introduced by Coco Chanel. Flying in the face of popular baroque ornamentation, she chooses a starkly simple, square-cut bottle with an unassuming black-and-white label. With its straightforward packaging and unsentimental title, Chanel Nº5 revolutionizes the perfume world, setting a new standard for modern simplicity.

1925 Shalimar by Guerlain embodies the spirit of the Roaring Twenties. Thanks to Shalimar's great success, Guerlain achieves international recognition.

1927 Jeanne Lanvin presents Arpège, an enormous success. Arpège is presented in an opaque, gold ball.

1930 Patou launches Joy—the most expensive fragrance in the world. To this day, Joy is considered the symbol of French *parfumerie*.

1944 Marcel Rochas has his first major success with Femme. He later presents Madame Rochas and Eau de Rochas.

1947 Dior presents Miss Dior, complementing his New Look.

1948 Nini Ricci introduces L'Air du Temps as a symbol of peace and eternal youth. Its celebrated bottle, created by Lalique, features a delicate stopper in the form of two doves.

1966 Eau Sauvage by Dior inspires a new era of androgynous fragrances.

1977 Yves Saint Laurent presents Opium, the most talked about fragrance since L'Air du Temps due to its provocative name and advertising image —memorably photographed by Helmut Newton.

1992 Thierry Mugler launches Angel in a striking, blue crystal bottle with a star-shaped stopper.

1993 Jean-Paul Gaultier presents his signature fragrance in a novel, female-body-shaped bottle inside a prosaic, metal can.

1999 Since its introduction in 1992, Angel by Mugler has continued to grow in popularity at an astounding rate. By 1999, it is outselling even Chanel Nº5.

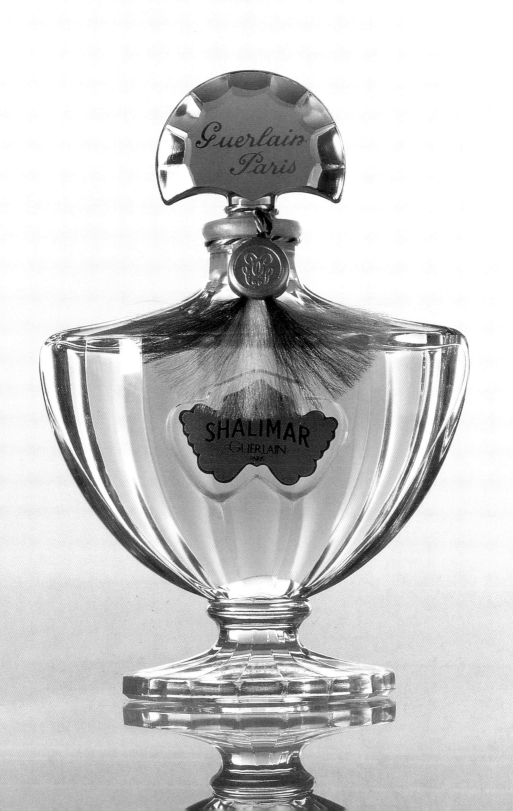

MAKEUP
Guidelines on "La Maquillage"

In keeping with her general principles of restraint, the Parisian woman veers away from extravagance in her daily application of makeup. She chooses colors that are light, natural, and that complement her skin tone: shades of beige, pink, terracotta, or chocolate, rather than brilliant red. She spends as much—or more—on skin-care products and beauty treatments as she does on makeup and prefers brands such as Chanel, Lancôme, Clarins, Dior, and Bourgois. On the other hand, she can be tempted by the latest trends: sparkles, fake tattoos, new shades of eyeshadow, or daring highlights for the hair—though it is doubtful they will see much use. For, when it comes to choosing her makeup for an actual soirée, she is more likely to stick to comfortable, conventional ideals of beauty. While her look may be more dramatic in the evening, she is careful not to cross the line into excess, favoring an appearance that is subtle, chic, and refined.

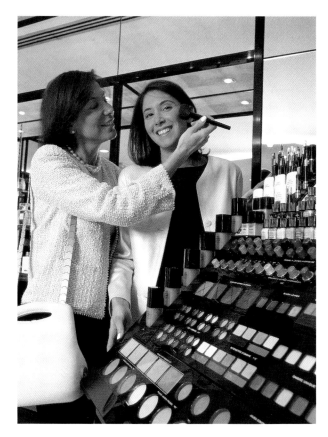

Dab of Color
Putting on the finishing touches at the Chanel makeup counter.

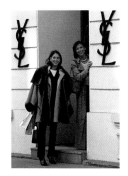

LE SHOPPING

The Insider's Guide

The city of Paris
is truly a shopper's
paradise. With such
a wealth of choices,
the only dilemma
is where to begin.
Here, a guided tour
of the Parisian
woman's favorite
sources.

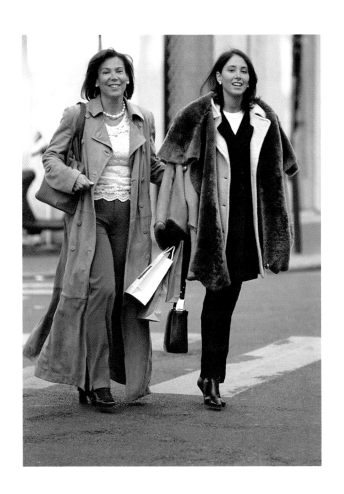

Le Shopping

For each entry, the *arrondissement*, district, in which the store is located is provided. For example, Le Bon Marché is located in the seventh arrondissement, Maria Luisa is in the first. When calling within France, add "01" before each phone number; from the U.S. add "011 33."

Department Stores

Le Bon Marché on the Left Bank is the Parisian woman's store of choice. Other department stores, such as Galeries Lafayette and Le Printemps, attract large crowds of tourists, whereas this smaller scale store is still very much the French woman's domain.

Le Bon Marché
22 rue de Sévres, 7th, 44 39 80 00

"LES BOUTIQUES MULTIMARQUES"
These stores offer merchandise from a selection of designers that reflect the particular spirit and taste of the boutique and cater to a more specific clientele than the large department stores.

L'Éclaireur
3 ter, rue des Rosiers, 3rd, 48 87 10 22
24 rue de l'Echaud, 6th, 44 27 08 03
26 avenue des Champs-Éysées, 8th, 45 62 12 32

Maria Luisa
2 rue Cambon, 1st, 47 03 96 15

Meredith
14 rue de Passy, 16th, 42 88 08 20

Onward
147 boulevard Saint-Germain, 6th, 55 42 77 55

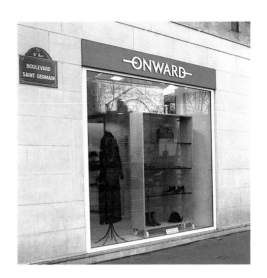

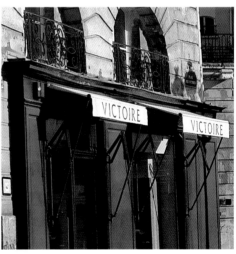

Victoire
12 place des Victoires, 12th, 42 61 09 02
1 rue Madame, 6th, 45 44 28 14
16 rue de Passy, 16th, 42 88 20 84

Le Shopping

Designer Boutiques

Agnès b.
6 rue du Jour, 1st, 45 08 56 56
6 rue de Vieux-Columbier, 6th, 44 39 02 60
81 rue d'Assas, 6th, 46 33 70 20
17 avenue Pierre-Ier-de-Serbie, 16th, 47 20 27 35

Un Après-Midi de Chien
10 rue du Jour, 1st, 40 26 92 78
3 bis, rue des Rosiers, 4th, 40 29 48 14
2 rue du Cherche-Midi, 6th, 45 44 05 32

Dorothée Bis
45 rue de Sèvres, 6th, 40 20 90 44

Barbara Bui
23 rue Étienne-Marcel, 1st, 40 26 43 65
43 rue des Francs-Bourgeois, 4th, 53 01 88 05
35 rue de Grenelle, 7th, 45 44 85 14

Corinne Cobson
45 rue de Sèvres, 6th, 40 49 02 04

Cacharel
5 place de Victoires, 1st, 42 21 38 38
64 rue Bonaparte, 6th, 40 46 00 45
34 rue Tronche, 9th, 47 42 12 61
Outlet: 114 rue d'Alésia, 14th, 45 42 53 04

Capucine Puerari
63 rue des Saints-Péres, 6th, 42 22 14 09

Nathalie Garçon
11 rue du Pré-aux-Clercs, 7th, 45 48 41 72

Daniel Hechter
31 rue Tronchet, 8th, 42 65 56 76
146 boulevard Saint-Germain, 6th, 43 26 96 36
2 place Passy, 16th, 42 88 01 11
4 ter, avenue Hoche, 8th, 47 63 11 40

Paule Ka
20 rue Mahler, 4th, 40 29 96 03
192 Boulevard Saint-Germain, 7th, 45 44 92 60

Isabel Marant
16 rue de Charonne, 11th, 49 29 71 55

Claudie Pierlot
1 rue Montmartre, 1st, 42 21 38 38
23 rue du Vieux-Coumbier, 6th, 45 48 11 96

Mon Ami Pierlot
(Claudie Pierlot's more casual line.)
3 rue Montmartre, 1st, 40 28 45 55

Regina Rubens
11 rue Pierre Sarrazin, 6th, 43 25 70 51
88 rue Alésia, 14th, 40 44 90 05
15 rue de Passy 16th, 45 20 56 56
7 Cité Paradis 10th, 48 01 05 05
207 rue Saint-Honoré, 1st, 45 44 96 95

Sonia Rykiel
175 boulevard Saint-Germain, 6th, 49 54 60 60
70 rue du Faubourg Saint-Honoré, 8th, 42 65 20 81

Corinne Sarrut
4 rue du Pré-aux-Clercs, 7th, 42 61 71 60
Outlet: 24 rue du Champ-de-Mars, 7th, 45 56 00 65
Outlet : 114 rue d'Alésia, 14th, 45 42 53 04
Bridal: 42 rue des Saints-Pères, 7th, 45 44 19 92

Le Shopping

Myrène de Prémonville
24 rue Boissy d'Anglas, 8th, 42 65 00 60

Ventilo
59 rue Bonaparte, 6th, 43 26 64 84
96 avenue Paul Doumer, 16th, 40 50 02 21
49 avenue Victor-Hugo, 16th, 40 67 71 70
267 rue Saint-Honoré, 1st, 40 15 61 41
27 rue Louvre, 1st, 42 33 18 67

Foreign Designers

Irié
8 rue du Pré-aux-Clercs, 7th, 42 61 18 28

Joseph
44 rue Étienne-Marcel, 2nd, 42 36 87 83
68 rue Bonaparte, 6th, 46 33 45 75
14 avenue Montaigne, 8th, 47 20 39 55
27 rue de Passy, 16th, 45 24 24 32

Tara Jarmon
18 rue du Four, 6th, 46 33 26 60
73 avenue des Champs-Élyseés, 8th, 45 63 45 41
51 rue de Passy, 16th, 45 24 65 20

Kenzo
3 place des Victoires, 1st, 40 39 72 03
16 boulevard Raspail, 7th, 42 22 09 38
18 avenue George-V, 8th, 42 61 04 14

Pleats Please
201 boulevard Saint-Germain, 7th, 45 48 10 44
3 place des Vosges, 4th, 48 87 01 86

Italian Favorites

Roberto Cavalli
68 rue du Faubourg-Saint-Honoré, 8th, 44 94 04 15

Dolce e Gabbana
2 avenue Montaigne, 8th, 47 20 42 43

Emporio Armani
25 place Vendôme, 1st, 42 61 02 34
149 boulevard Saint-Germain, 6th, 53 63 33 50

Gucci
350 rue Saint-Honoré, 1st, 42 96 83 27
2 rue du Faubourg-Saint-Honoré, 8th, 53 05 11 11

Prada
5 rue de Grenelle, 6th, 45 48 53 14
70 rue des Saints-Péres, 7th, 45 44 59 17
10 avenue Montaigne, 8th, 53 23 99 40

Miu Miu (line of Prada)
10 rue du Cherche-Midi, 6th, 45 48 63 33

Trussardi
8 place Vendôme, 1st, 55 35 32 50

Le Shopping

Quintessential Parisian Luxury

Éric Bergère
13 rue Yves-Toudic, 10th, 42 06 36 46

Céline
58 rue de Rennes, 6th, 45 48 58 55
3 avenue Victor-Hugo, 16th, 45 01 80 01

Chanel
31 rue Cambon, 1st, 42 86 28 00
42 avenue Montaigne, 8th, 47 23 74 12

Christian Dior
30 avenue Montaigne, 8th, 40 73 54 44
46 rue du Faubourg-Saint-Honoré, 8th, 44 51 55 51
16 rue Abbaye, 6th, 56 24 90 53

Inès de la Fressange
14 avenue Montaigne, 8th, 47 23 08 94

Jean Paul Gaultier
6 rue Vivienne, 2nd, 42 86 05 05

Hèrmes
24 rue du Faubourg-Saint-Honoré, 8th, 40 17 47 17

Christian Lacroix
2 place Saint-Sulpice, 6th, 46 33 48 95
73 rue du Faubourg-Saint-Honoré, 8th, 42 68 79 00
26 avenue Montaigne, 8th, 47 20 68 95

Christophe Lemaire
53 rue Saint-Sabin, 11th, 47 00 52 32

Didier Ludot
20-24 galerie Montpensier, 1st, 42 96 06 56

Jérome L'huillier
27 rue de Valois, 1st, 49 26 07 07

Discounted Haute Couture Fabrics

Tissu Edré
16 rue Jean Bologne, 16th, 46 47 60 18
142 rue Ordener, 18th, 42 54 28 35

Custom-made Couture

Jacqueline Peres
4 rue de Castiglione, 1st, 42 60 67 42

Vintage Couture

Réciproque
95 rue de la Pompe, 16th, 47 04 30 28

Pourquoi Pas?
14 bis, avenue Bosquet, 7th, 47 53 74 08

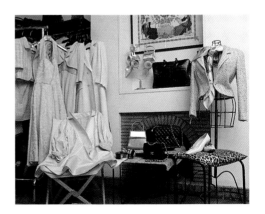

Le Shopping

Discount Shops

La rue D'Alésia, 14th

A well kept Parisian bargain hunter's secret, this street is filled with discount branches of quality boutiques such as Chevignon, Dorothée Bis, Regina Rubens, and much more.

Sexy Evening Clothes

Azzedine Alaïa
7 rue de Moussy, 4th, 42 72 19 19

Hervé Léger
29 rue du Faubourg-Saint-Honoré, 8th, 44 51 62 36

Lolita Lempicka
14 rue du Faubourg-Saint-Honoré, 8th, 49 24 94 01
46 avenue Victor-Hugo 16th, 45 02 14 46
Outlet: 2 rue des Rosiers, 4th, 48 87 09 67
Bridal (Les Mariées de Lolita): 15 rue Pavée, 4th,
48 04 96 96

Thierry Mugler
10 place des Victoires, 2nd, 49 26 05 02
45 rue du Bac, 7th, 45 44 44 44
49 avenue Montaigne, 8th, 47 23 37 62

Plein Sud
14 place des Victoires, 2nd, 42 36 75 02
21 rue des Francs-Bourgeois, 4th, 42 72 10 60
70 bis, rue Bonaparte, 6th, 43 54 43 06
Outlet: 21 rue Sevant, 11th, 49 29 71 49

Young, Hip Style

Phillipe Adec
323 rue Saint Martin, 3rd, 42 72 91 46

33 rue Four, 6th, 43 26 82 44

Autour du Monde-Bensimon
12 rue Frances Bourgeois, 3rd, 42 77 16 18

APC
3 rue de Fleurus, 6th, 42 22 12 77
25 bis, rue Benjamin-Franklin, 16th, 45 53 28 28
Jeans and Accessories: 45 rue Madame, 6th, 45 48 43 71
Outlet: 32 rue Cassette, 6th, 45 48 43 71

Aridza Bross
5 rue des Canettes, 6th, 46 33 48 50
Outlet: 24 rue Saint-Denis, 2nd, 40 26 32 23

Vanessa Bruno
24 rue Saint-Sulpice, 6th, 43 54 41 04

Diab'less
39 rue de Caire, 2nd, 42 36 03 54

Diapositive
12 rue Jour, 1st, 42 21 34 41
42 rue Four, 6th, 45 48 85 57
12 rue Pré-aux-Clercs, 7th, 45 44 75 02

Et Vous
6 rue des Francs-Bourgeois, 3rd, 42 71 75 11
64 rue de Rennes, 6th, 45 44 23 75
25 rue Royale, 8th, 47 42 31 00
Outlet: 15-17 rue de Turbigo, 2nd, 40 13 04 12

Free
32 rue du Four, 6th, 45 44 23 11
84 avenue des Champs-Élysées, 8th, 43 59 19 59

Le Shopping

Tara Jarmon
73 avenue des Champs-Élysées, 8th, 45 63 45 41
18 rue Four, 6th, 46 33 26 60
51 rue de Passy, 16th, 45 24 65 20

Kiliwatch
39 rue du Caire, 2nd, 42 36 03 54

Kookaï
19 rue Monnaie, 1st, 40 41 05 61
82 rue Réaumur, 2nd, 45 08 51 00
111 rue Mouffetard, 5th, 43 31 70 68
35 boulevard Saint-Michel, 5th, 46 34 75 02
155 rue de Rennes, 6th, 45 48 26 36
2 rue Gustave Courbet, 16th, 47 55 18 00
106 rue Faubourg Saint Antoine, 12th, 43 45 83 23
42 rue Lévis, 17th, 42 27 31 81

Morgan
165 rue de Rennes, 6th, 45 48 96 77
81 rue de Passy, 16th, 45 27 20 09

Les Petites
10 rue Four, 6th, 55 42 98 78
53 rue de Passy, 16th, 42 24 48 88

Toi du Monde
7 rue du Jour, 1st, 40 13 09 32

Bill Tornade
44 rue Étienne-Marcel, 2nd, 42 33 66 47

Zara
Forum des Halles, 1st, 55 34 98 51
128 rue de Rivoli, 1st, 44 82 64 00
45 rue de Rennes, 6th, 44 39 03 50
44 avenue des Champs-Élysées, 8th, 45 61 52 80
2 rue Halvéy, 9th, 44 71 90 90
109 rue Saint-Lazare, 9th, 53 32 82 95
53 rue de Passy, 16th, 45 25 07 00

Lingerie

LUXURIOUS

Alice Cadolle
(Custom and ready to wear)
14 rue Cambon, 1st, 42 60 94 94

Christian Dior
46 rue du Faubourg-Saint-Honoré, 8th, 44 51 55 51

CLASSIC

Capucine Puerari
63 rue des Saints-Péres, 6th, 42 22 14 09

Les Folies d'Elodie
56 avenue Paul Doumer, 16th, 45 04 93 57

Sabbia Rosa
73 rue des Saints-Péres, 6th, 45 48 88 37

Le Shopping

YOUNG AND LESS EXPENSIVE

Ci Dessous
48 rue du Four, 6th, 42 84 25 31
42 rue de Passy, 16th, 45 25 91 99
4 avenue des Ternes, 17th, 43 80 06 05
11 rue Vavin, 6th, 43 54 46 91

Etam
1 rue Pierre Lescot, 1st, 42 33 88 07
17 rue Arrivée, 15th, 43 27 03 04
67 rue de Passy, 16th, 55 74 00 74
61 rue Lévis, 17th, 46 22 48 20

Petit Bateau
61 rue de Sèvres, 6th, 45 49 48 38
61 rue de Grenelle, 7th, 47 05 18 51
13 rue Tronchet, 8th, 42 65 26 26
55 rue du Commerce, 15th, 45 77 88 00
60 bis, rue Dombasle, 15th, 45 30 22 54
41 rue Vital, 16th, 45 25 55 19

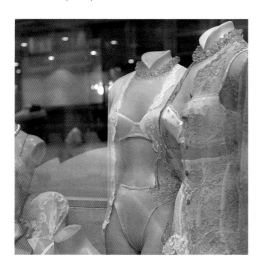

Princesse Tam-Tam
23 rue de Grenelle, 7th, 45 49 28 73
60 rue du Commerce, 15th, 44 19 45 50
2 rue Guichard, 16th, 42 15 18 85
83 rue de Courcelles, 17th, 47 66 42 23
25 rue Tronchet, 8th, 40 17 07 41
9 rue Bréa, 6th, 55 42 14 72

Bathing Suits

Erès
4 bis, rue du Cherche-Midi, 6th, 45 44 95 54
2 rue Tronchet, 8th, 47 42 28 82
6 rue Guichard, 16th, 46 47 45 21

Hervé Léger
29 rue du Faubourg-Saint-Honoré, 8th, 44 51 62 36

Capucine Puerari
63 rue des Saints-Péres, 6th, 42 22 14 09

Shoes

PARISIAN FAVORITES

Accessoire Diffusion
8 rue du Jour, 1st, 40 26 19 84
36 rue Vielle-du-Temple, 4th, 40 29 99 49
6 rue du Cherche-Midi, 6th, 45 48 36 08
Additional Line: Accessoire Détente, 11 rue du Pré-aux-
Clercs, 7th, 42 84 26 85
Additional Line: Lundi Bleu, 23 rue du Cherche-Midi,
6th, 42 22 47 94

Robert Clergerie
46 rue Croix-des-Petits-Champs, 1st, 42 61 49 24

Le Shopping

5 rue du Cherche-Midi, 6th, 45 48 75 47
18 avenue Victor-Hugo, 16th, 45 01 81 30

Maud Frizon

83 rue des Saints-Péres, 7th, 42 22 06 93
90 rue du Faubourg-Saint-Honoré, 8th, 42 65 27 96

Charles Kammer

14 rue de Grennelle, 7th, 42 22 35 13

Stéphane Kélian

6 place des Victoires, 2nd, 42 61 60 74
36 rue de Sévigné, 3rd, 42 77 87 91
13 bis, rue de Grenelle, 7th, 42 22 93 03
26 avenue des Champs-Élysées, 8th, 42 56 42 26
23 boulevard de la Madeleine, 8th, 42 96 01 84
20 avenue Victor-Hugo, 16th, 45 00 44 41

Michel Perry

4 bis, rue des Petits-Pères, 2nd, 42 44 10 07

CLASSIC

Charles Jourdan

5 boulevard de la Madeleine, 1st, 42 61 15 89
86 avenue des Champs Élysées, 8th, 45 62 29 28

Parallèle

9 rue de Sèvres, 6th, 45 48 90 53
21 rue Plaine, 20th, 43 56 80 27
13 rue Marivaux, 2nd, 42 96 04 03

HIGH DESIGN

Christian Louboutin

19 rue Jean-Jacques-Rousseau, 1st, 42 36 05 31
38 rue de Grenelle, 7th, 42 22 33 07

Rodolphe Menudier

49 rue de Lancry, 10th, 42 40 75 75

INEXPENSIVE

Shoe Bizz

25 rue Beaubourg, 3rd, 42 74 72 40
48 rue Beaubourg, 3rd, 48 87 12 73
42 rue du Dragon, 6th, 45 44 93 50

YOUNG AND TRENDY

Colisée de Sacha

64 rue de Rennes, 6th, 40 49 02 13

Patrick Cox

62 rue Tiquetonne, 2nd, 40 26 66 55
21 rue de Grenelle, 7th, 45 49 24 28

Free Lance

22 rue Mondétour, 1st, 42 33 74 70
30 rue du Four, 6th, 45 48 14 78

Miu-Miu

10 rue du Cherche-Midi, 6th, 45 48 63 33

Mosquitos

19 rue Pierre-Lescot, 1st, 45 08 44 72
25 rue du Four, 6th, 43 25 25 16
99 rue de Rennes, 6th, 45 48 58 40
12-14 rue Gustave-Courbet, 16th, 45 53 36 73

Le Shopping

ITALIAN

Prada
5 rue de Grenelle, 6th, 45 48 53 14
70 rue des Saints-Péres, 7th, 45 44 59 17
10 avenue Montaigne, 8th, 53 23 99 40

Sergio Rossi
22 rue de Grenelle, 7th, 42 84 07 24
11 rue du Faubourg-Saint-Honoré, 8th, 40 07 10 89

J. P. Tods
52 rue du Faubourg-Saint-Honoré, 8th, 42 66 66 65

Leather Goods

Richard Gampel
13 rue de Passy, 16th, 42 15 24 25

Didier Lamarthe
219 rue Saint-Honoré, 1st, 42 96 09 90
19 rue Daunou, 2nd, 42 61 02 66

Lancel
4 rd-pt Champs-Élysées M. Dassault, 8th, 42 25 18 35
127 avenue des Champs-Élysées, 8th, 44 31 41 41
8 place de l'Opéra, 9th, 47 42 37 29
43 rue de Rennes, 6th, 42 22 94 73
93 rue de Passy, 16th, 40 50 30 06

Longchamp
21 rue Vieux Colombèr, 6th, 42 22 74 75

Louis Vuitton
174 boulevard St. Germain, 6th, 44 39 06 45
101 avenue des Champs-Élysées, 8th, 53 57 24 00
5 rue Babylone, 7th, 45 44 95 95

6 place St. Germain des Prés, 6th, 45 49 62 32

Designer Hats

Marie Mercié
56 rue Tiquetonne, 2nd, 40 26 60 68
23 rue Saint-Sulpice, 6th, 43 26 45 83

Philippe Model
33 place du Marché-Saint-Honoré, 1st, 42 96 89 02

Jewelry

Cartier
102 rue Provence, 9th, 42 82 40 71
13 rue Paix, 2nd, 42 18 53 70
23 rue Faubourg-Saint-Honoré, 8th, 44 94 87 70
7 place Vendôme, 1st, 53 93 95 20

O.J. Perrin
33 avenue Victor-Hugo, 16th, 45 01 88 88
8 rue Royale, 8th, 42 61 88 88
8 rue Paix, 2nd, 42 92 08 08

Costume Jewelry

Le Shopping

Gioia
16 rue Jean Bologne, 16th, 45 20 40 94

Réminiscence
26 avenue des Champs-Élysées, 8th, 53 75 10 86
42 rue Étienne-Marcel, 2nd, 42 21 36 82
22 rue du Four, 6th, 46 33 32 61

Perfume

Annick Goutal
14 rue Castiglione, 1st, 42 60 52 82
12 place Saint-Sulpice, 6th, 46 33 03 15
16 rue de Bellchasse, 7th, 45 51 36 13
93 rue de Courcelles, 17th, 46 22 00 11

L'Artisan Parfumeur
32 rue du Bourg-Tibourg, 4th, 48 04 55 66
24 boulevard Raspail, 7th, 42 22 23 32
22 rue Vignon, 9th, 42 66 32 66

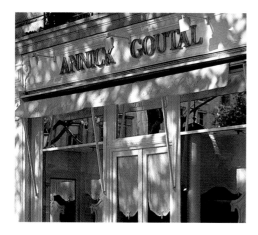

Boucheron
20 rue de la Paix, 2nd, 42 44 42 44

Caron
34 avenue Montaigne, 8th, 47 23 40 82

Chanel
31 rue Cambon, 1st, 42 86 28 00
42 avenue Montaigne, 8th, 47 23 74 12

Guerlain
2 place Vendôme, 1st, 42 60 68 61
29 rue de Sèvres, 6th, 42 22 46 60
47 rue Bonaparte, 6th, 43 26 71 19
68 avenue des Champs-Élysées, 8th, 45 62 52 57
35 rue Tronchet, 8th, 47 42 53 23
Centre Maine Montparnasse, 15th, 43 20 95 40
93 rue de Passy, 16th, 42 88 41 62

Octée
18 rue des Quatre-Vents, 6th, 46 33 18 77

Jean Patou
7 rue Saint-Florentin, 8th, 44 77 33 00

Michel Swiss
Carries all brands of perfume at reasonable prices, as well as beauty products and leather goods, such as bags by

Le Shopping

Longchamps and Didier Lamarthe.
16 rue de la Paix, 2nd, 42 61 61 11
24 avenue de l'Opéra, 1st

Hair Salons

Camille Albane
47 rue Bonaparte, 6th, 46 33 59 57

Carita International
11, rue Faubourg-Saint-Honoré, 8th, 44 94 11 11

Jean-Louis David
Locations throughout the city—consult local listings.

Jacques Dessange
43 avenue Franklin-Roosevelt, 8th, 43 59 31 31
24 avenue de la Bourdonnais, 7th, 45 50 41 33
17 rue de l'Arrivée, 15th, 43 20 44 66
52 bis, rue d'Auteuil, 16th, 42 24 71 24
63 avenue de Villiers, 17th, 46 22 12 15

Jean-Marc Maniatis
35 rue de Sèvres, 6th, 45 44 16 39
12 rue du Four, 6th, 46 34 79 83
18 rue Marbeuf, 8th, 47 23 30 14

Lucie St. Clair
5 rue des Petits-Champs, 1st, 42 60 01 00
17 rue du Dragon, 6th, 45 44 84 17
103 rue Saint-Dominiques, 7th, 47 05 99 45
3 rue Vignon, 8th, 42 68 02 20
29 rue de Marignan, 8th, 42 25 10 01
20 avenue du Maine, 15th, 45 48 00 40
4 avenue Pierre-Iere-de-Serbie, 16th, 47 20 53 54
12 rue Jean Bologne, 16th, 40 50 09 50
115 rue de Courcelles, 17th, 47 66 73 60

Alexandre Zouari
1 avenue du Président Kennedy, 16th, 47 23 79 00

Salons de Thé

Angélina
226 rue de Rivoli, 1st, 42 60 82 00
10 place de Mexico, 16th
Palais des Congrès, 2 place de la Porte Maillot, 17th,
40 68 22 51

A Priori Thé
35-37 galerie Vivienne, 2nd, 42 97 48 75

Ladurée
75 avenue des Champs-Élysées, 8th, 40 75 08 75
16 rue Royale, 8th, 42 60 21 79
1st floor of Printemps Haussmann, 9th, 42 82 40 10
2nd floor of Franck et Fils, 8 rue de Passy, 16th,
44 14 38 80

Les Deux Magots
6 place Saint Germain-des-Prés, 6th, 45 48 55 25

Thé Cool
10 rue Jean Bologne, 16th, 42 24 69 13

Le Shopping U.S.

Department Stores

Barneys
Azzedine Alaïa, Armani, Chanel (cosmetics only), Diab'less, Dolce & Gabbana, Jean-Paul Gaultier, Hermès, Irié, Christian Lacroix, Miu Miu, Claudie Pierlot , Plein Sud, Prada, Capucine Puerari

Bergdorf Goodman
Céline, Chlöe, John Galliano (Dior), Hervé Léger, Thierry Mugler, Jean Paul Gaultier, Céline, Chanel, Dior, Joseph, Armani, Dolce & Gabbana, Claudie Pierlot, Capucine Puerari, Erès

Bloomingdales
Jean Paul Gaultier, Chanel, Gucci (accessories only), Armani, D&G, Sonia Rykiel

Marshall Field's
Sonia Rykiel, Hermès, Armani, Yves Saint-Laurent, Rive Gauche, Thierry Mugler, Jean-Paul Gaultier, John Galliano (Dior)

Neiman Marcus
Thierry Mugler, Christian Lacroix, Hervé Léger, Céline

Saks Fifth Avenue
Chanel, Thierry Mugler, Christian Lacroix

Individual Designer Boutiques

Agnès b.
Boston, Chicago, Los Angeles, New York, San Francisco

APC
New York

Emporio Armani
Beverly Hills, Boston, Costa Mesa, Honolulu, Houston, Las Vegas, Montreal, New York, San Francisco, Toronto

Barbara Bui
New York

Robert Clergerie
Los Angeles, New York

Céline
Beverly Hills, Honolulu, New York, San Francisco

Chanel
Aspen, Bal Harbour, Beverly Hills, Boston, Chicago, Dallas, Honolulu, Houston, Las Vegas, Maui, New York, Palm Beach, San Francisco, Washington D.C.

Patrick Cox
New York

Christian Dior
Aspen, Bal Harbour, Beverly Hills, Boston, Honolulu, Houston, Las Vegas, Maui, New York

Free Lance
New York

Gucci
Aspen, Atlanta, Bal Harbour, Beverly Hills, Boston, Charleston, Chicago, Dallas, Honolulu, Houston, Maui, Las Vegas, New Orleans, New York , Palm Beach, Pheonix, San Francisco; call 800.388.6785 for complete listings

Hermès
Atlanta, Beverly Hills, Boston, Chicago, Dallas,

Le Shopping U.S.

Honolulu, Houston, Las Vegas, New York, Palm Beach, San Francisco; call 800.441.4488 for complete listings

Joseph
Miami, New York

Charles Jourdan
Bal Harbour, Beverly Hills, Honolulu, New York, Palm Beach

Stéphane Kélian
New York

Kenzo
Costa Mesa, Los Angeles, New York

Miu Miu
New York, Los Angeles

Petit Bateau
There are no Petit Bateau boutiques in the U.S., but Anik, Forreal, and Scoop in New York carry the line.

Prada
Bal Harbour, Chicago, New York; call 888.977.1900 for complete listings

Sergio Rossi
Bal Harbour, New York

Sonia Rykiel
Boston, Chicago, Honolulu, New York, Palm Beach

J. P. Tods
Bal Harbour, Beverly Hills, Chicago, New York

Louis Vuitton
Atlanta, Beverly Hills, Boston, Chicago, Dallas, Denver, Las Vegas, Los Angeles, New York, Palm Beach, San Diego, San Francisco, Scottsdale; call 800.458.7930 for complete listings

Zara
New York

Perfumes and Cosmetics

Many French perfumes and cosmetics can be found in department stores throughout the U.S. A recent, extraordinary addition to the U.S. scene is the French cosmetics "superstore" Sephora—in New York, San Francisco, San Diego, Las Vegas, Seattle, Honolulu, and Miami—which carries most brands.

Glossary

Clothing

bathing suit: maillot de bain
(one/two piece: une/deux pieces)
blouse: chemisier
boatneck: col bateau
bodysuit: body
bow: noeud
bra: soutien gorge
bustier: bustier
buttons: boutons
camisole: combinette
cape: pelerine, cape
cardigan: cardigan
coat: manteau
collar: col
crew neck: col rond
cuff: manchette
dress: robe
evening suit: le smoking
hood: capuche
jacket: gilet (cardigan or light jacket),
blouson (outerwear), veste (suit jacket or blazer)
lacing: laçage
nightgown or nightshirt: chemise de nuit
pullover: pull
robe: robe de chambre
shirt: chemise
skirt: jupe
sleeves: manches (short/long: manches courtes/longues)
slip: jupon
snaps: boutons pression
socks: chaussettes
square neck: col carré
stockings: bas
stole: étole
straps: bretelles
suit: tailleur
tights: collants
turtleneck: col roulé
underpants: caleçon, slip, culottes
underwear: lingerie, dessous
V-neck: col en V
wrap skirt: jupe portefeuille
zipper: fermeture éclair

Shoes and Accessories

bag: sac
belt: ceinture
belt buckle: cigle
boots: bottes (high), bottines (low), "boots"
flat shoes: chaussures plats
gloves: gants
handbag: sac à main
heels: talons
knapsack: sac à dos
platforms: compensés
pumps: escarpins
scarf: foulard (silk), echarpe
shoes: chaussures
sneakers: baskets
spike heels: talons aiguilles

Styles, Shapes, Patterns, and More

big: grand
bright: vif
casual: decontracte
color: couleur
colorful: coloré
comfortable: confortable
cut: coupe
dark: foncé
dots: petit pois
draped: drapé
dressed up/elegant: habillé
embroidered: brodé
flounces: volants
flowers: fleurs
flowing: fluide
fringe: frange
full: ample
gathers: fronces
knitted: tricoté
light: clair (color), léger (weight)
line: ligne
long: long
loose: large
narrow: étroit
opaque: opaque

Glossary

pinstripe: rayures tennis
pleats: plis
quilted: matelassé
refined: raffiné
shape: forme
shiny: brillant
short: court
size: taille
small: petit
striped: rayé
subtle: subtil
thick: epais
thin: fine
tight: serré
transparent: transparent

Colors

beige: beige
black: noir
blue: bleu
brown: marron
charcoal gray: anthracite
eggplant: aubergine
flesh colored: couleur chair
gray: gris
green: vert
ivory: ivoire
khaki: kaki
navy: bleue marine
orange: orange
pink: rose
purple: violet
red: rouge
sky blue: blue de ciel
white: blanc
wine: bordeaux
yellow: jaune

Materials

cashmere: cachemire
cotton: coton
crushed velvet: panne de velours
elastic: élastique

fake fur: fausse fourrure
feathers: plumes
felt: feutre
fur: fourrure
lace: dentelle
leather: cuir
satin: satin
sequins: paillettes
silk: soie
suede: daim
taffeta: taffetas
velvet: velours
wool: laine

Jewelry

bracelet: bracelet
chain: chaine
choker: collier de chien
cuff: bracelet manchette
earrings: boucles d'oreille
hanging earrings: boucles pendants
necklace: collier
pin: broche
ring: bague
watch: montre
wire: fil métallique

Jewelry Materials

bead: perle
brass: laiton
copper: cuivre
crystal: cristal
diamond: diamant
glass: verre
gold: or
jet: jais
mother of pearl: nacre
pearl: perle
platinum: platine
resin: résine
rhinestone: faux diamant
semiprecious stones: pierres dures
silver: argent

Virginie and
Véronique Morana
are the owners
of Gioia, an elegant
costume jewelry
boutique located in
Paris's well-heeled
16th arrondissement.
Featured in such
international fashion
magazines as *Paris
Capitale*, *L'Officiel*,
and *Madame Figaro*
Japan, the Moranas'
boutique is heralded
for its unique
designs from notable
costume jewelers
around the world.